MANDALAS TO COLOR

Prefer Stress Relief Book To Experience A Healthy Lifestyle

Mandala Craft Art

Copyright © 2019 by Mandala Craft Art

All Rights Reserved. No part of this publication may be reproduced, distributed, or transmitted in any form or by any means, including photocopying, recording, or other electronic or mechanical methods.

This book belongs to:

Color Swatch

Test your color supplies on this page to see how they react to the paper. Place a blank page or two behind each page as your color, to prevent bleed-through to the next page.

Color this mandala!

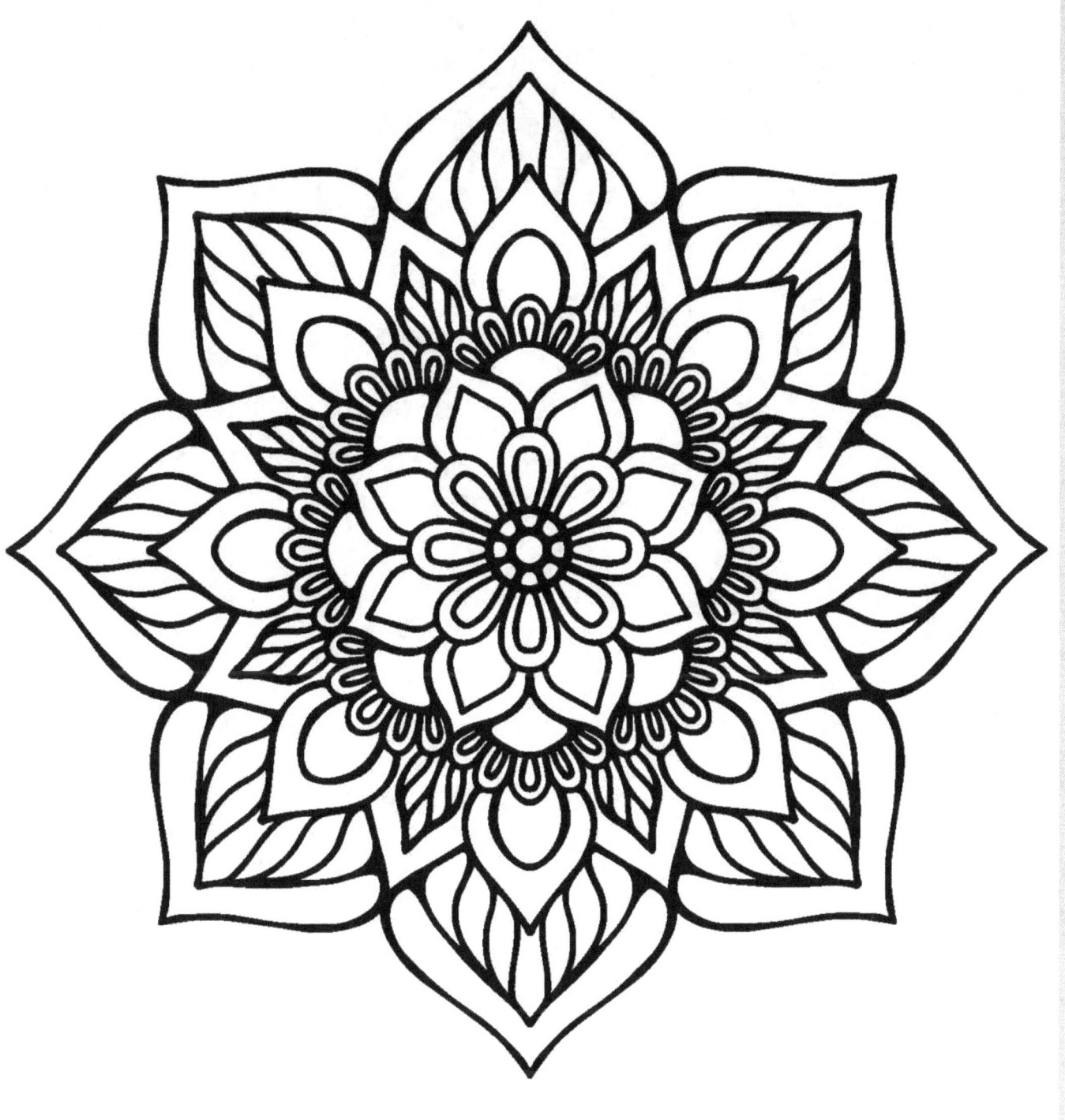

Color this mandala!

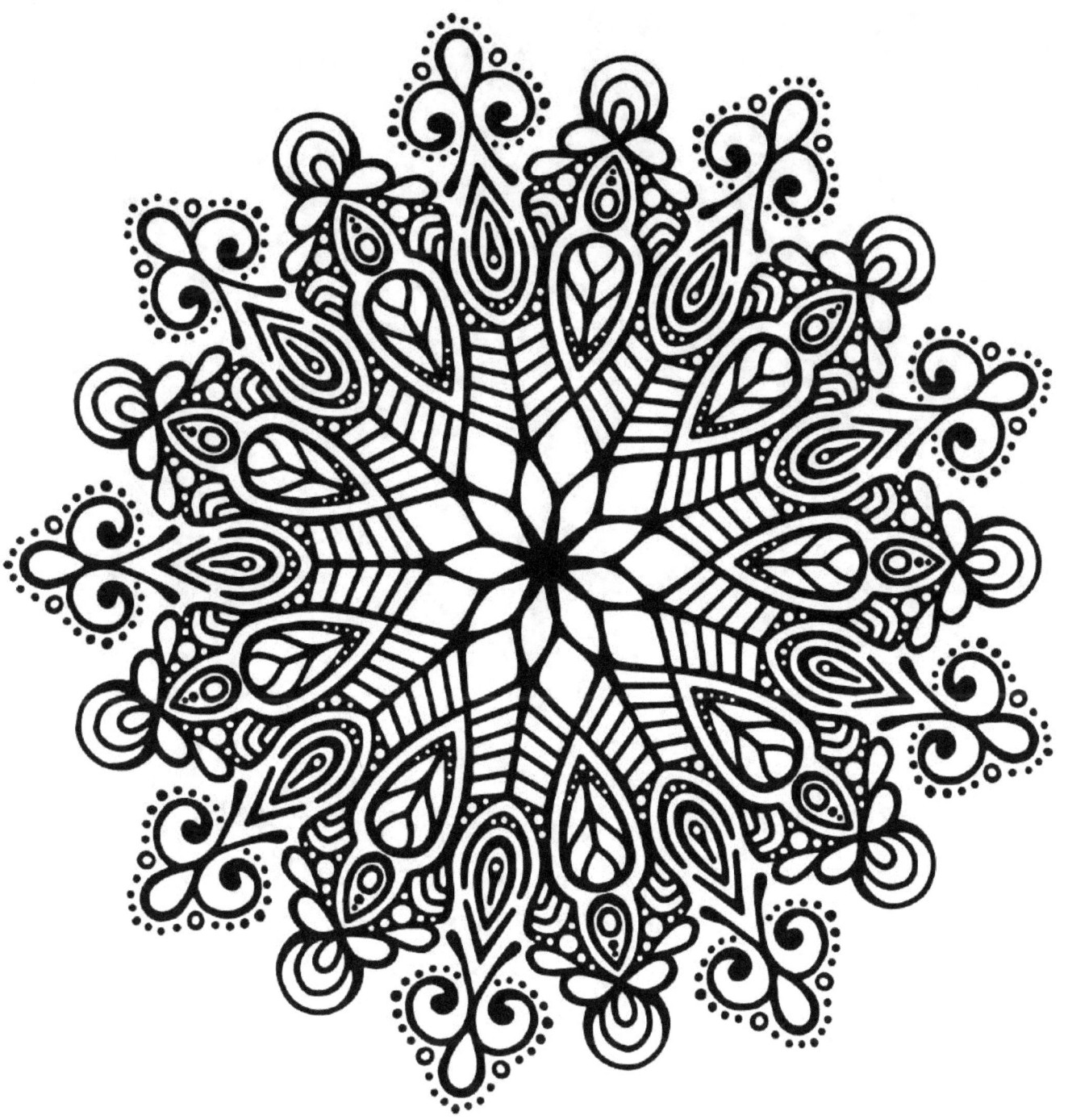

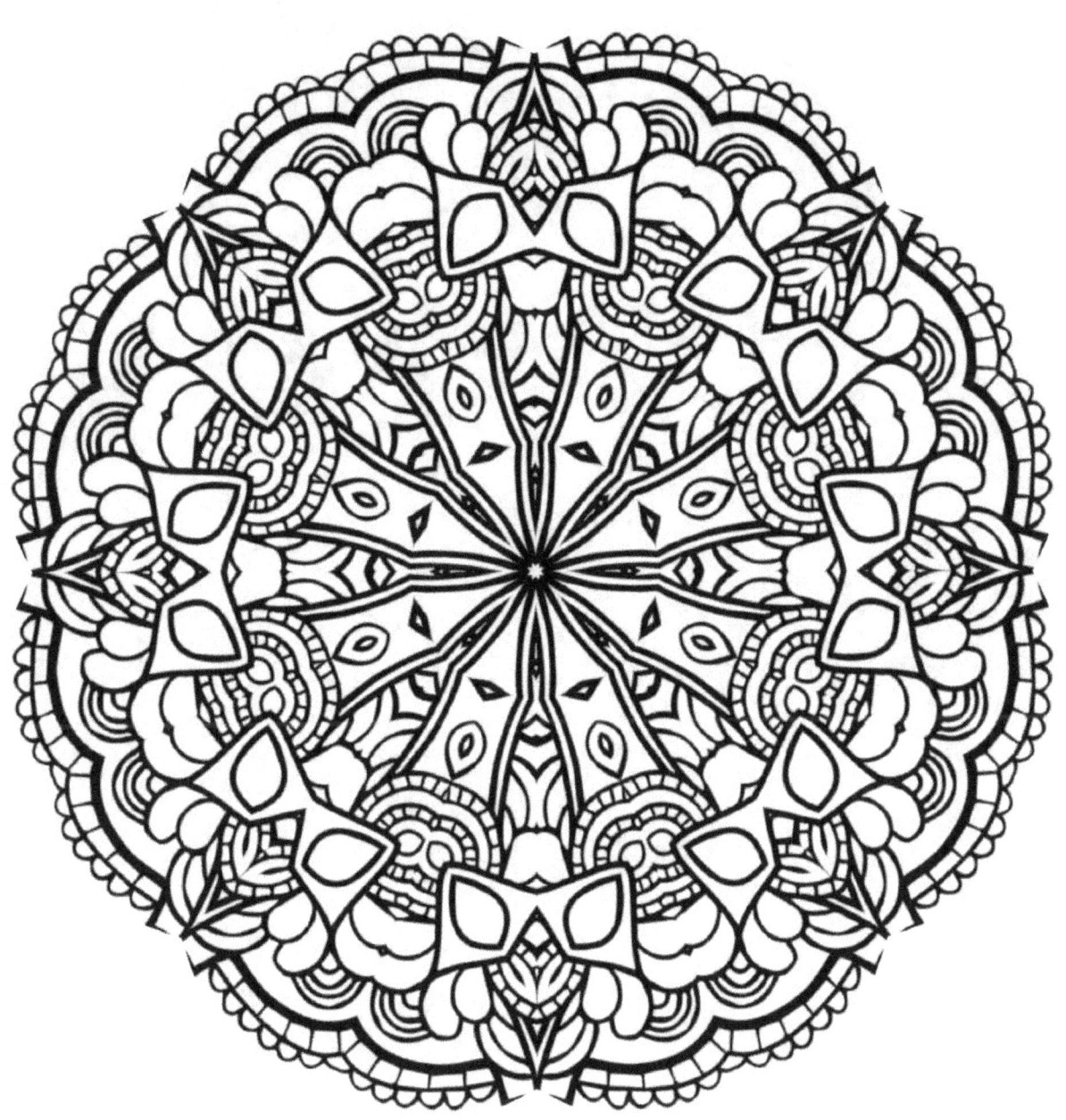

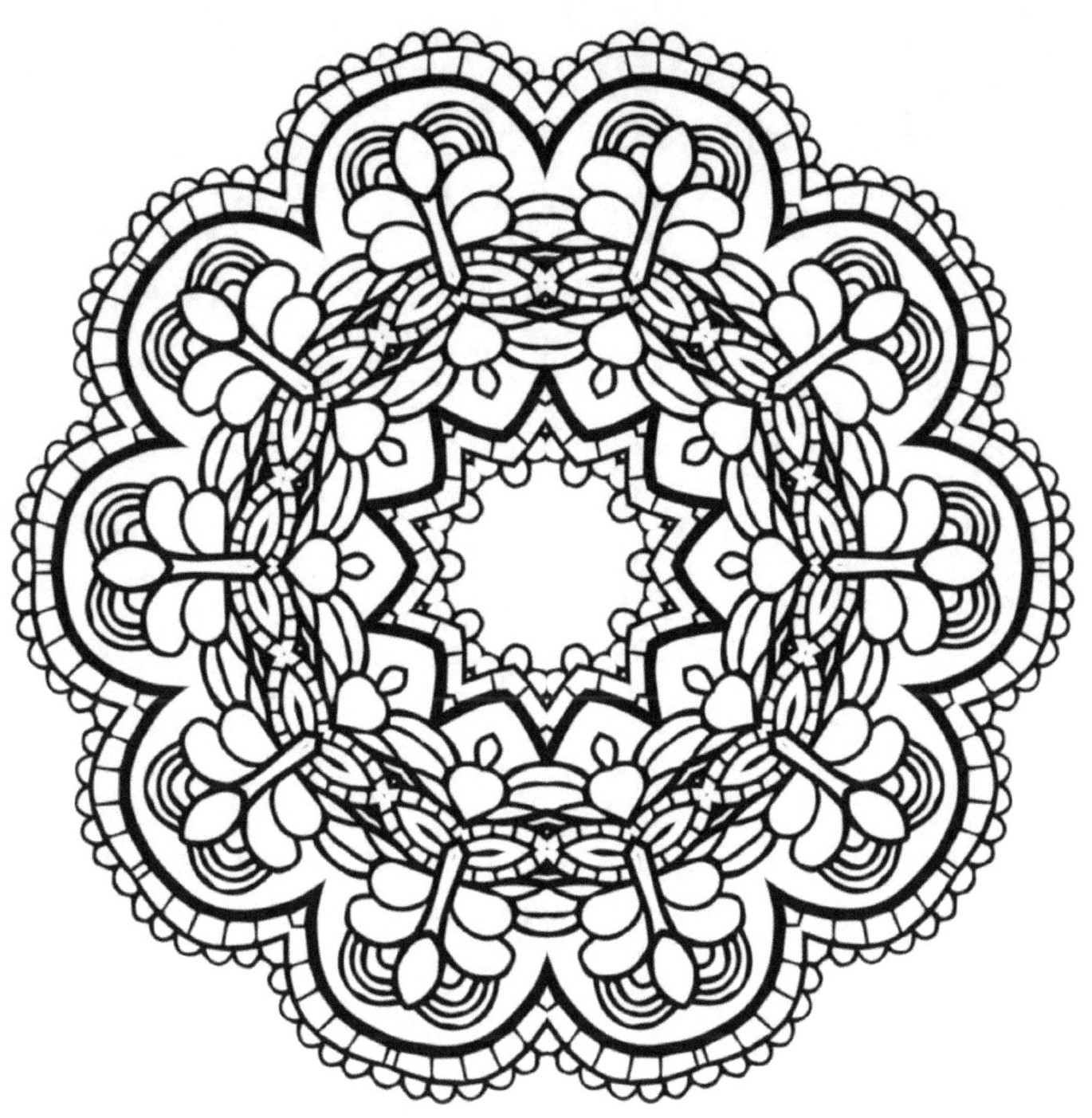

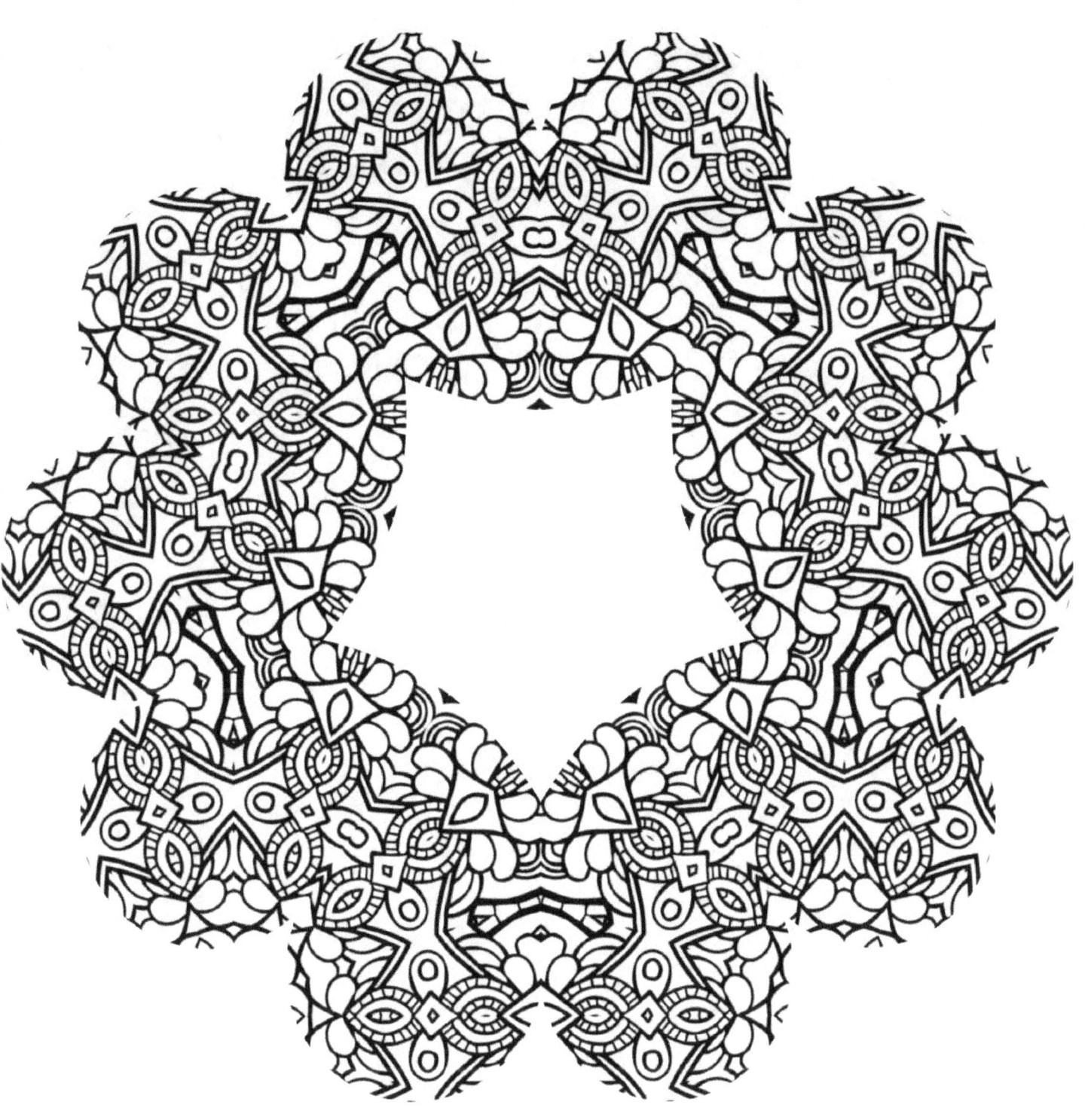

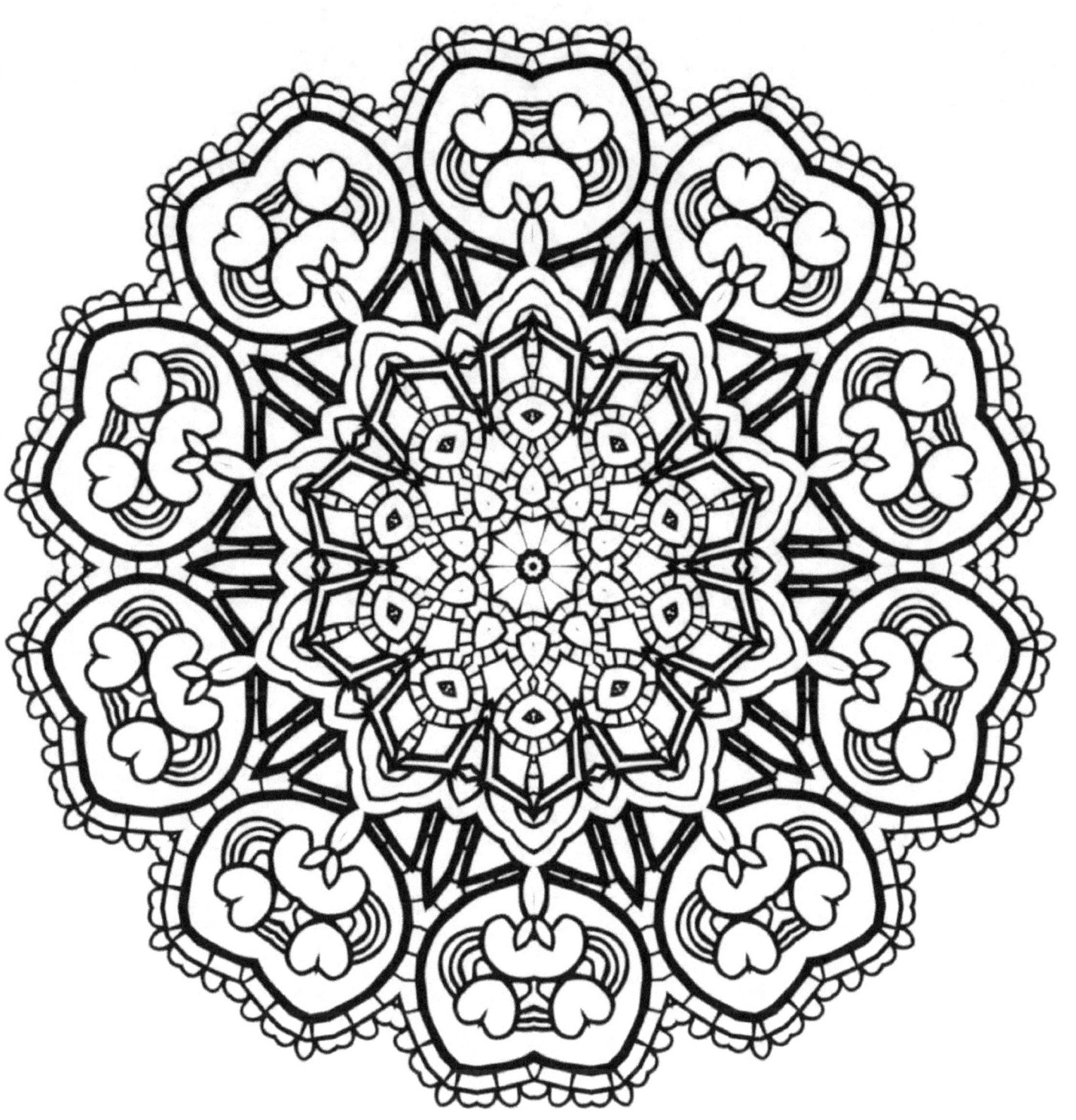

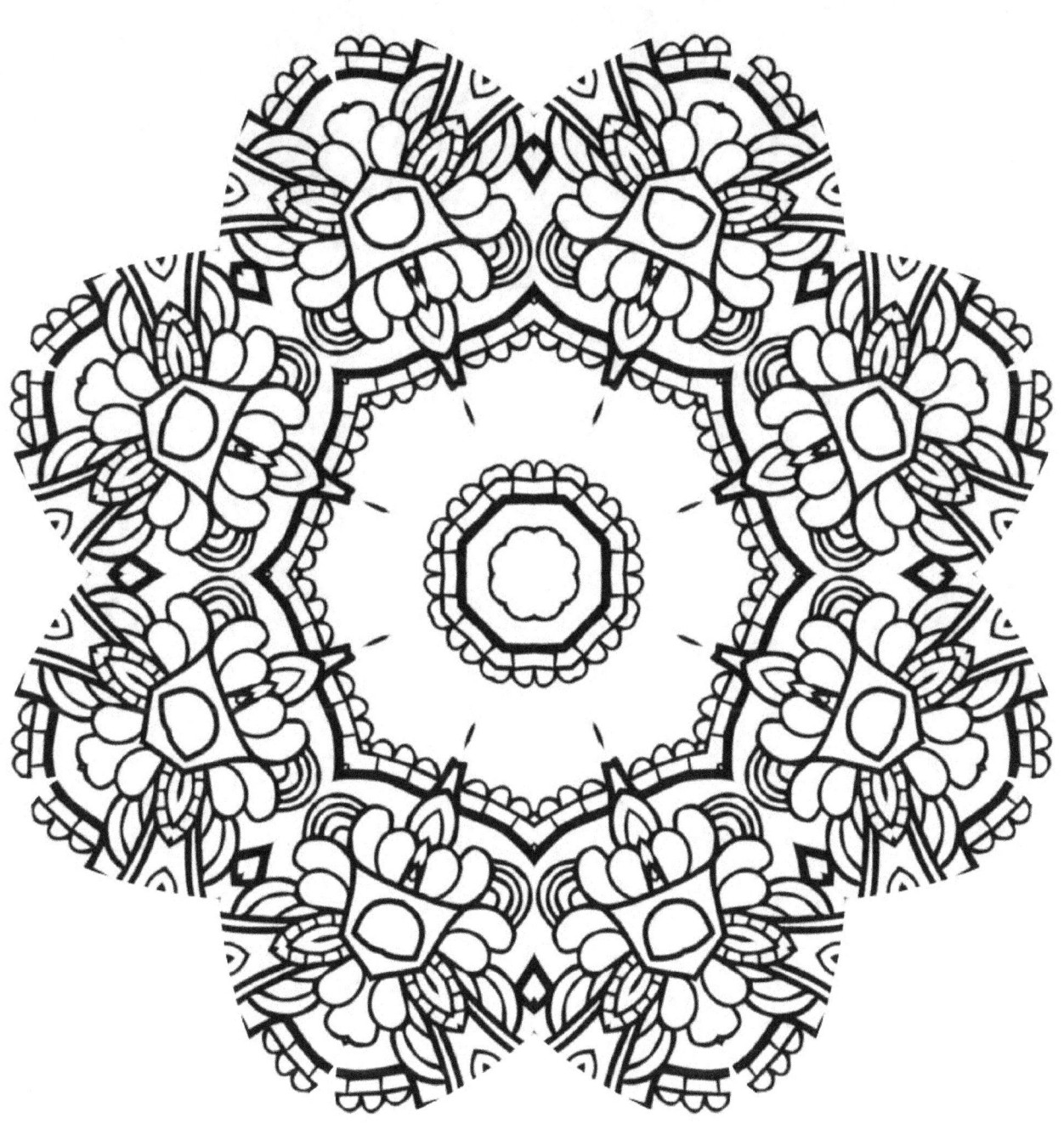

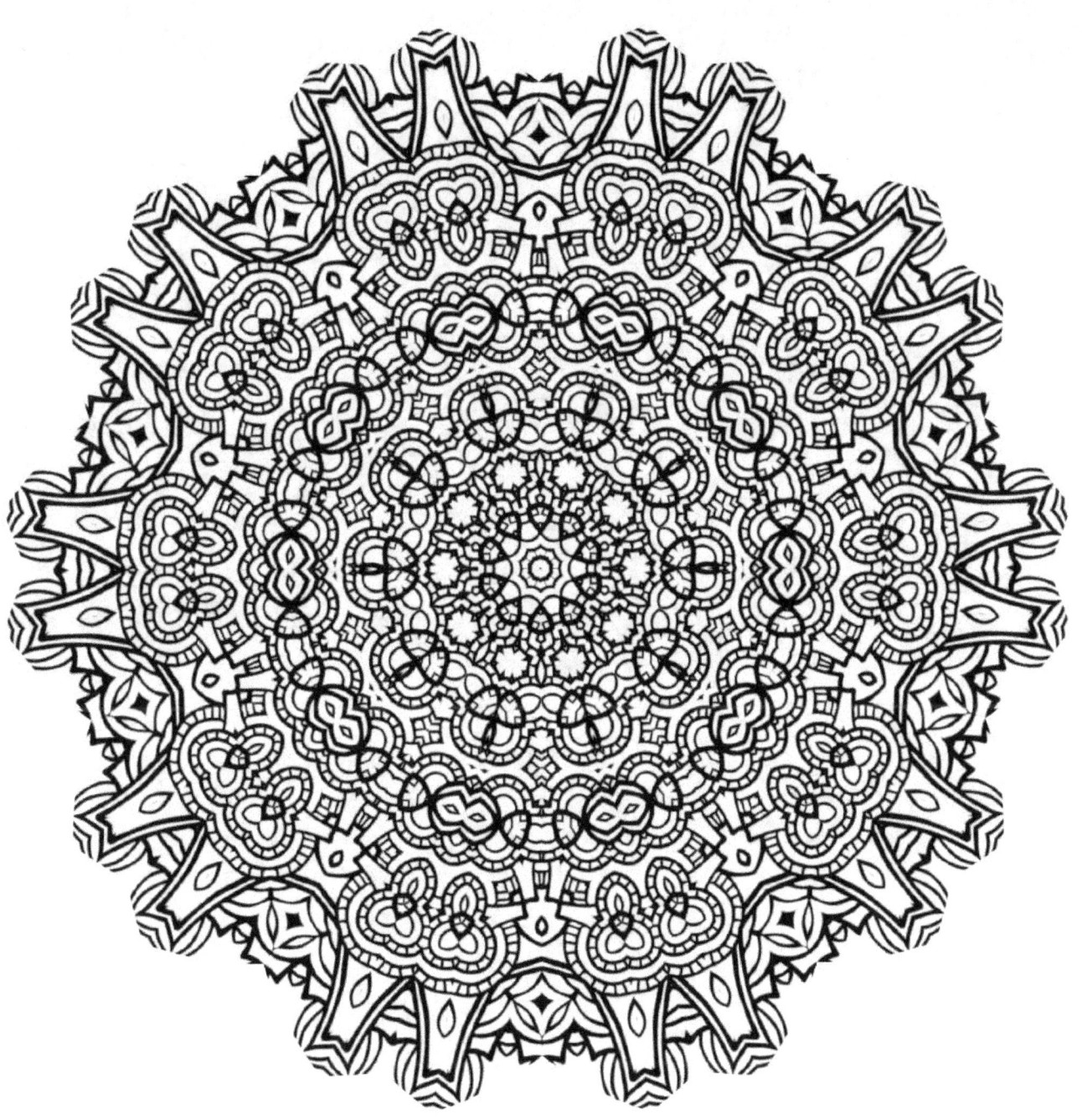

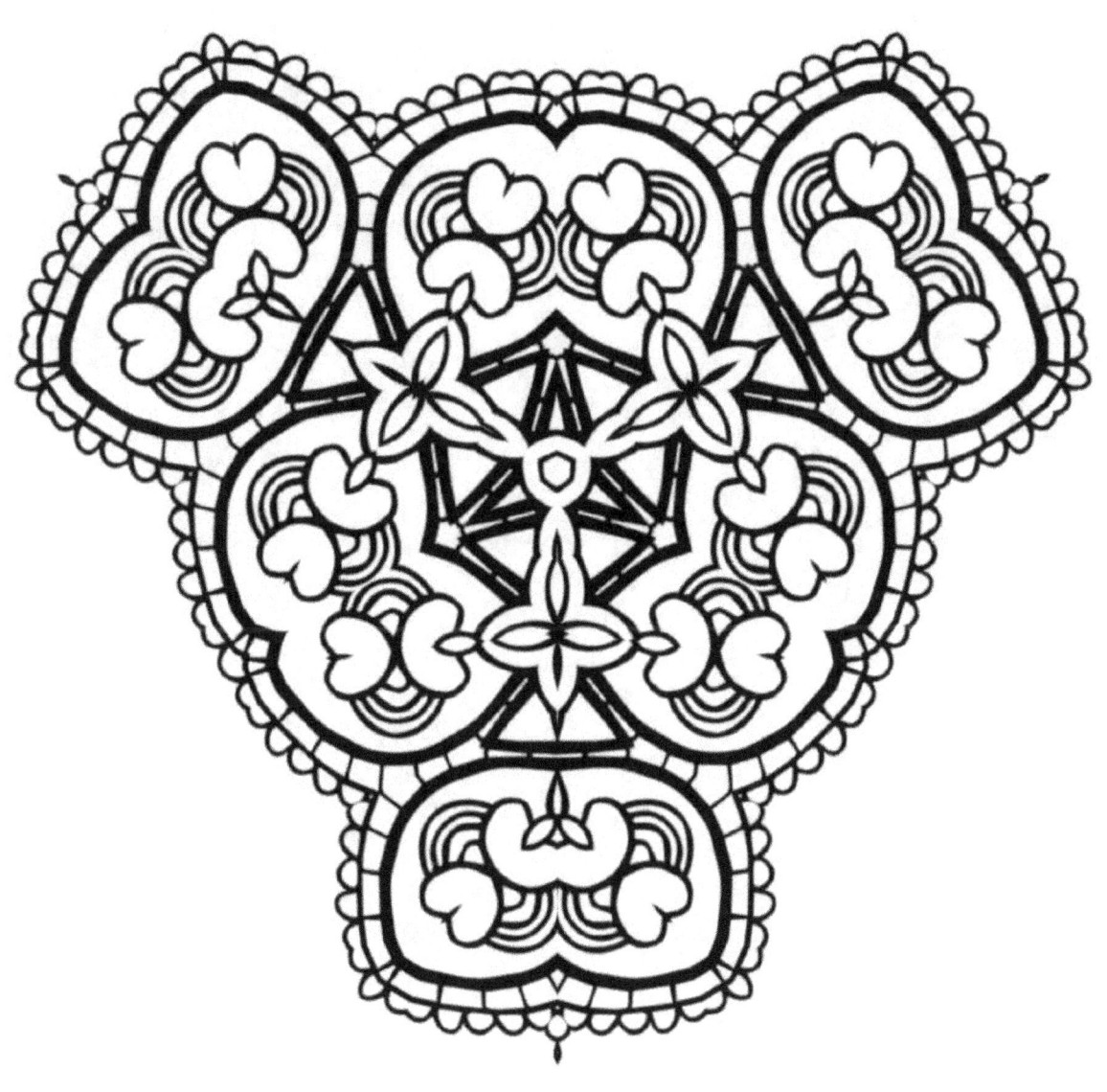

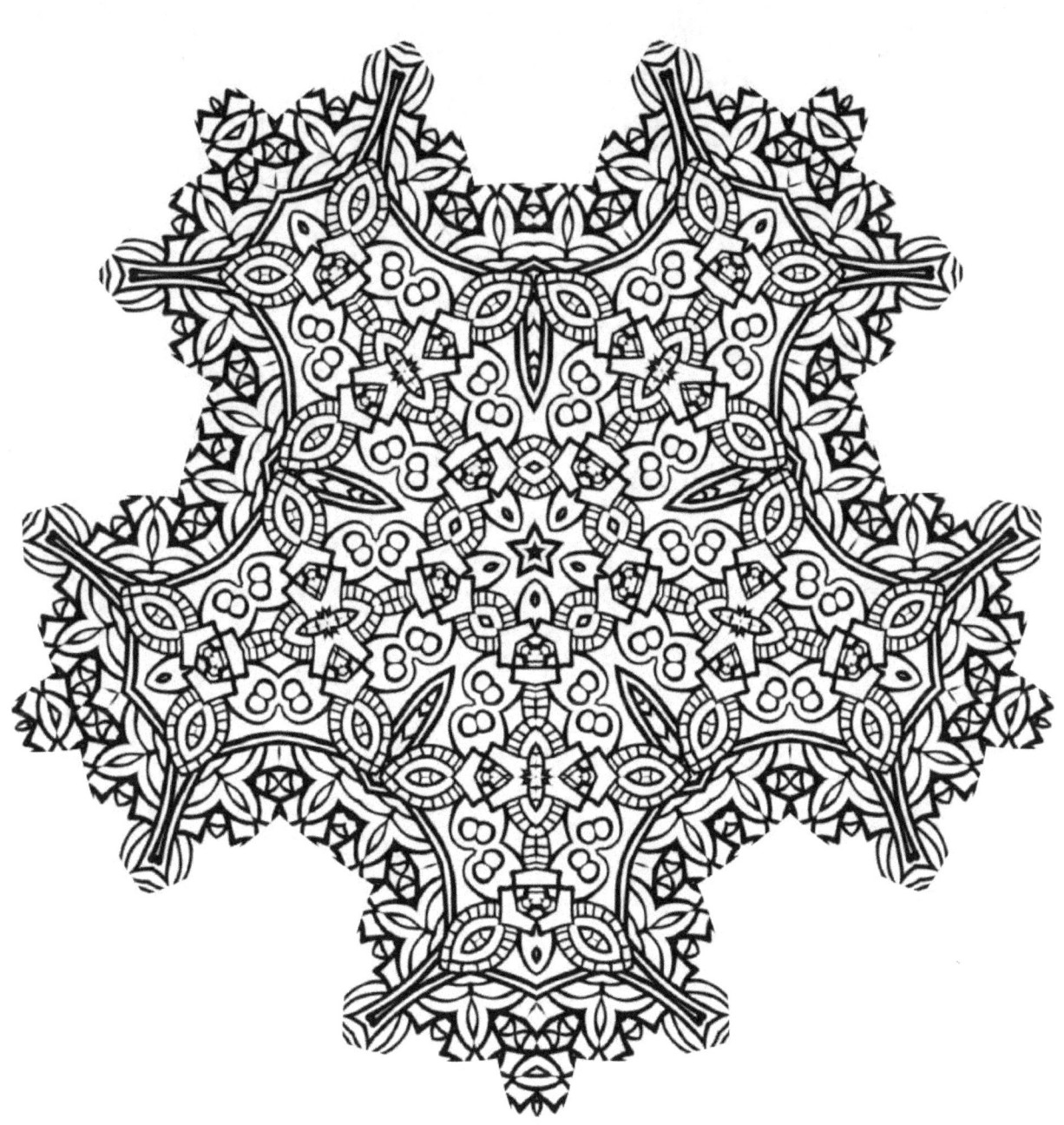

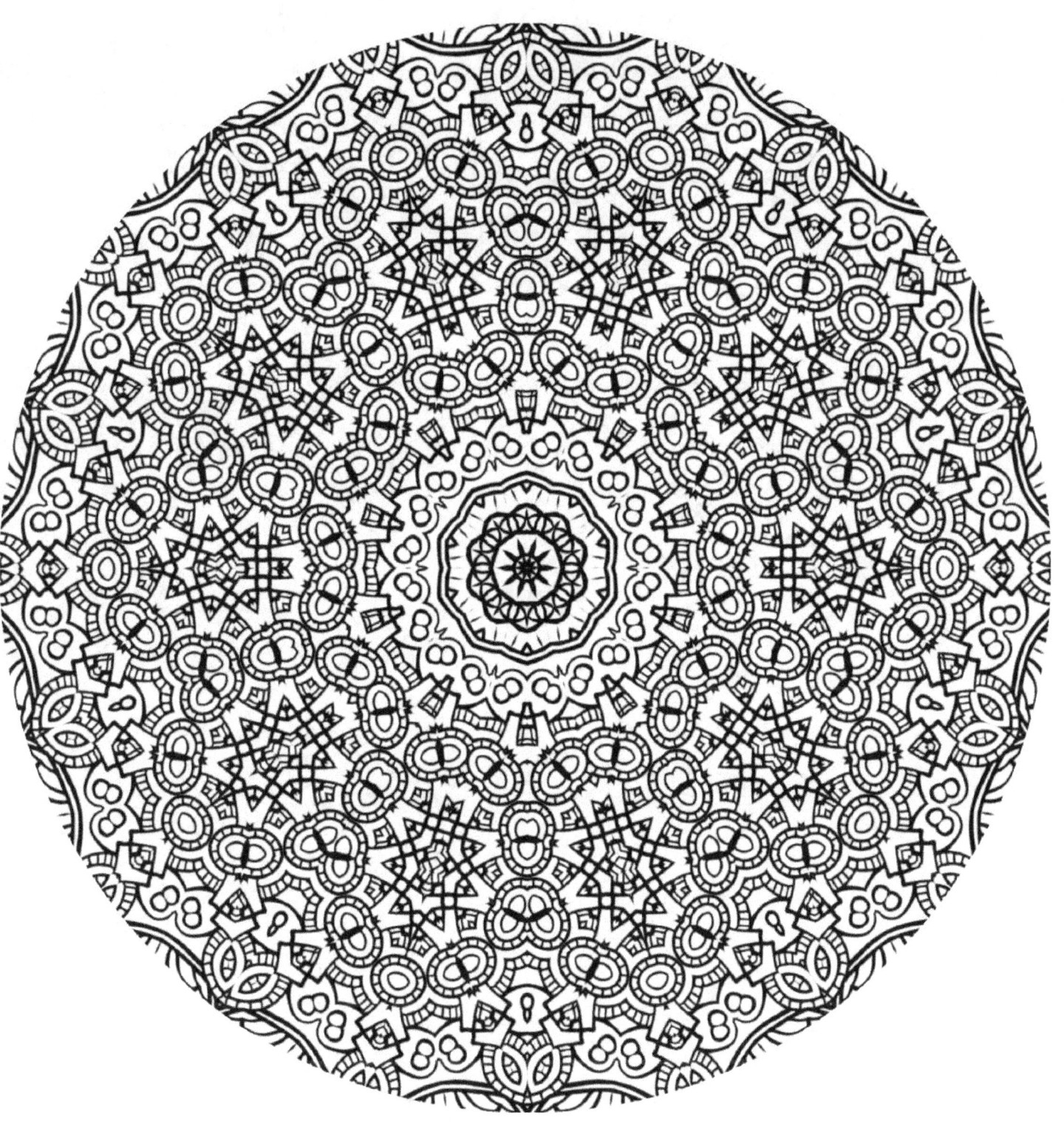

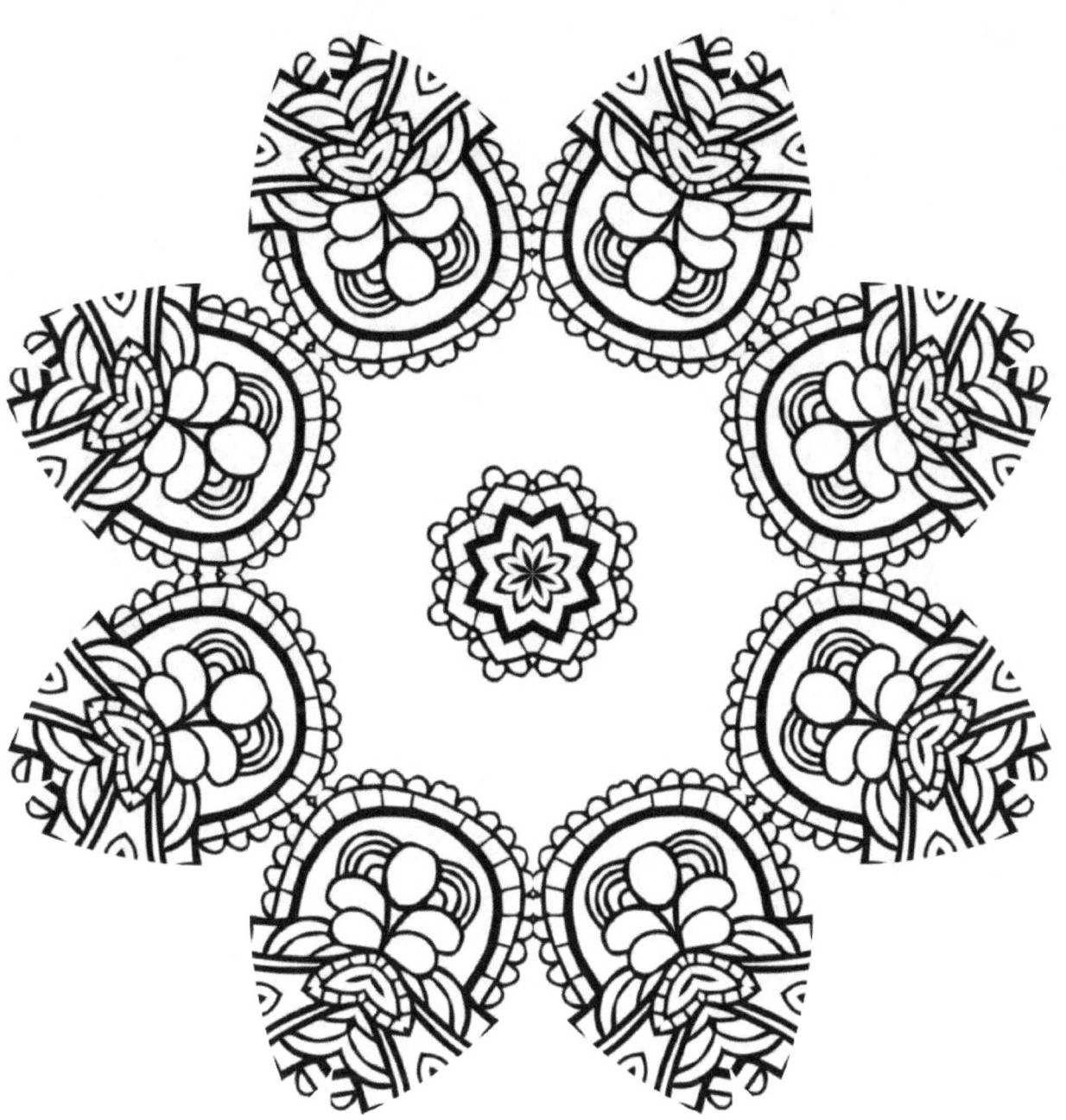

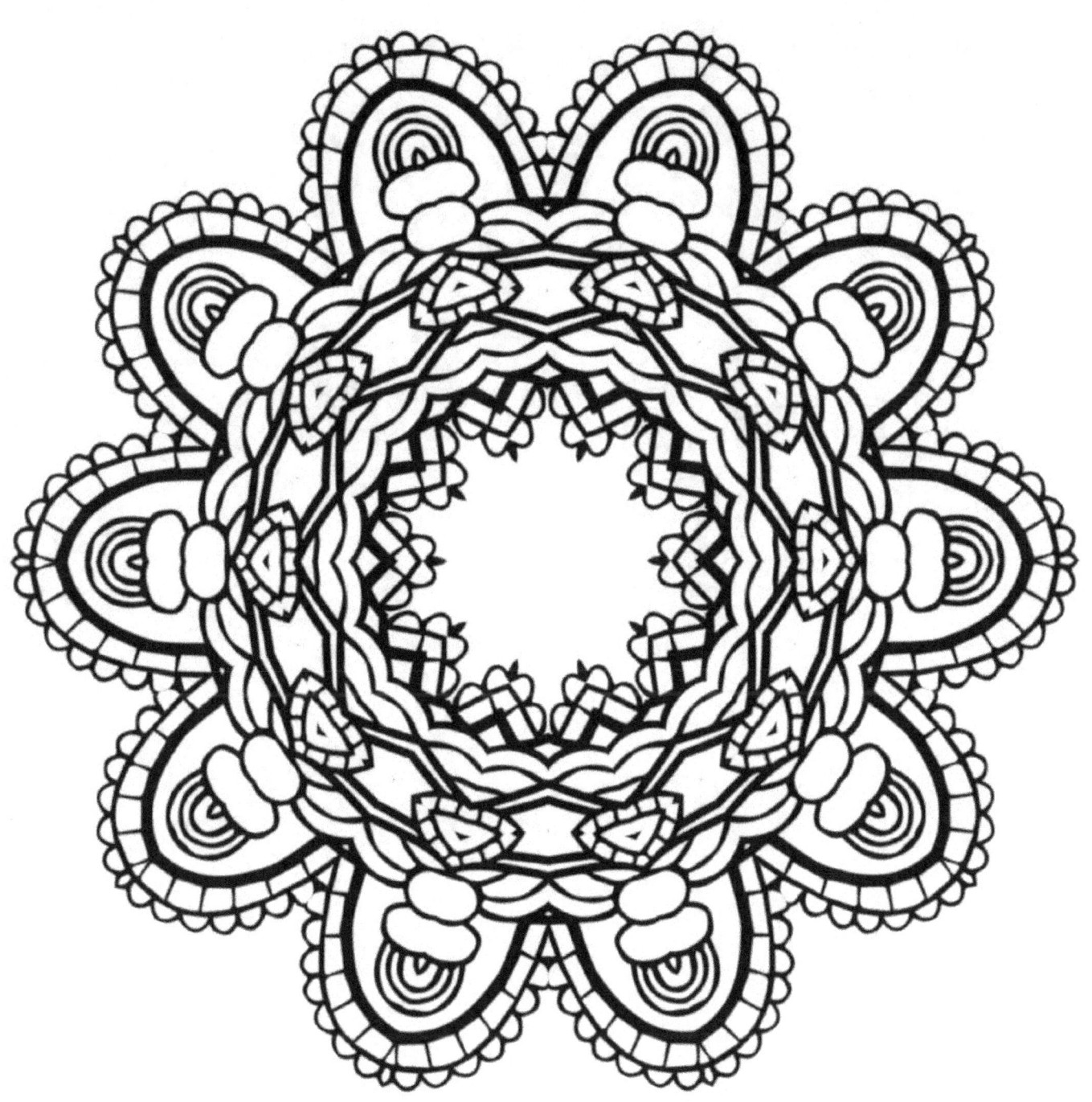

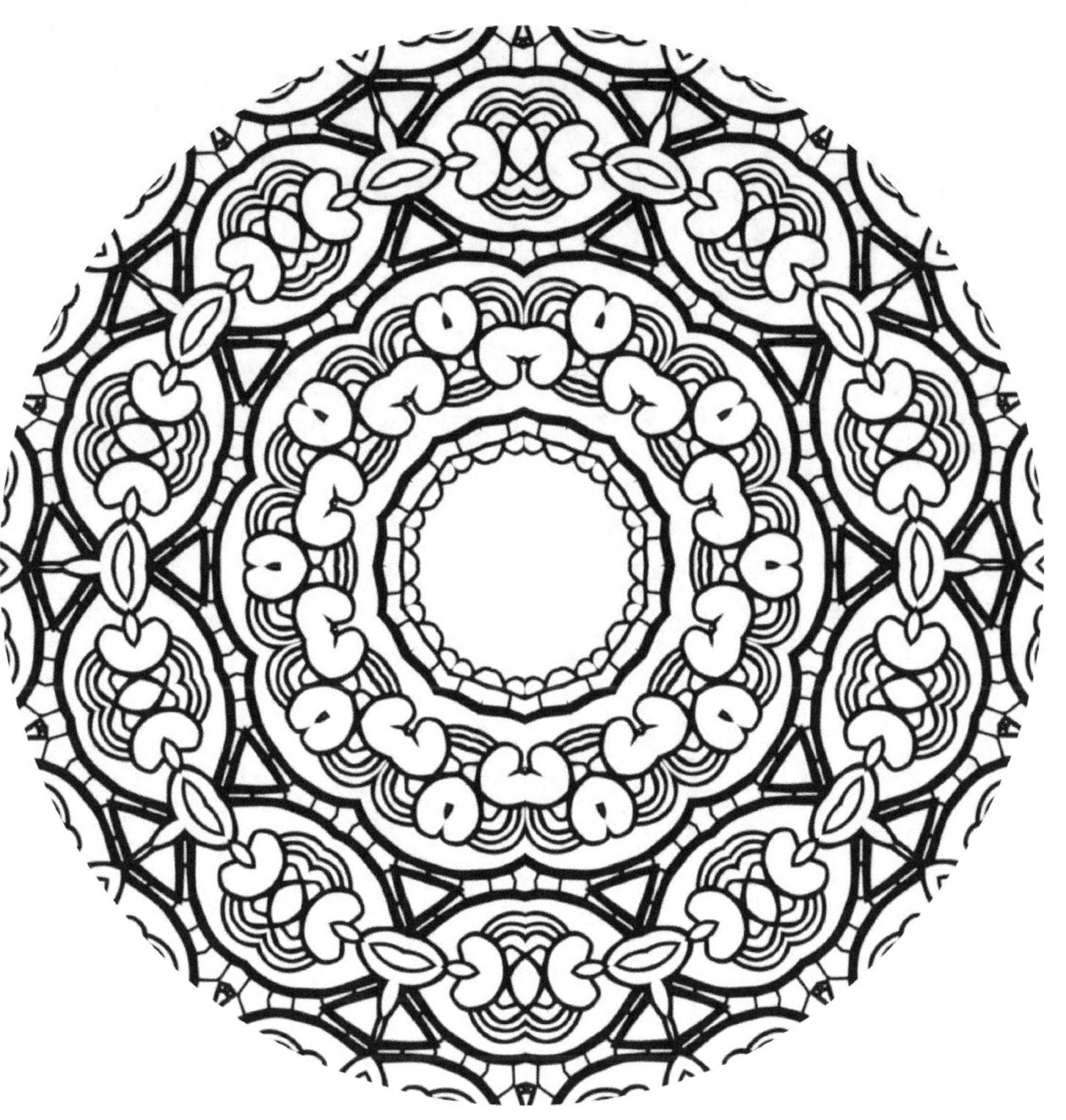

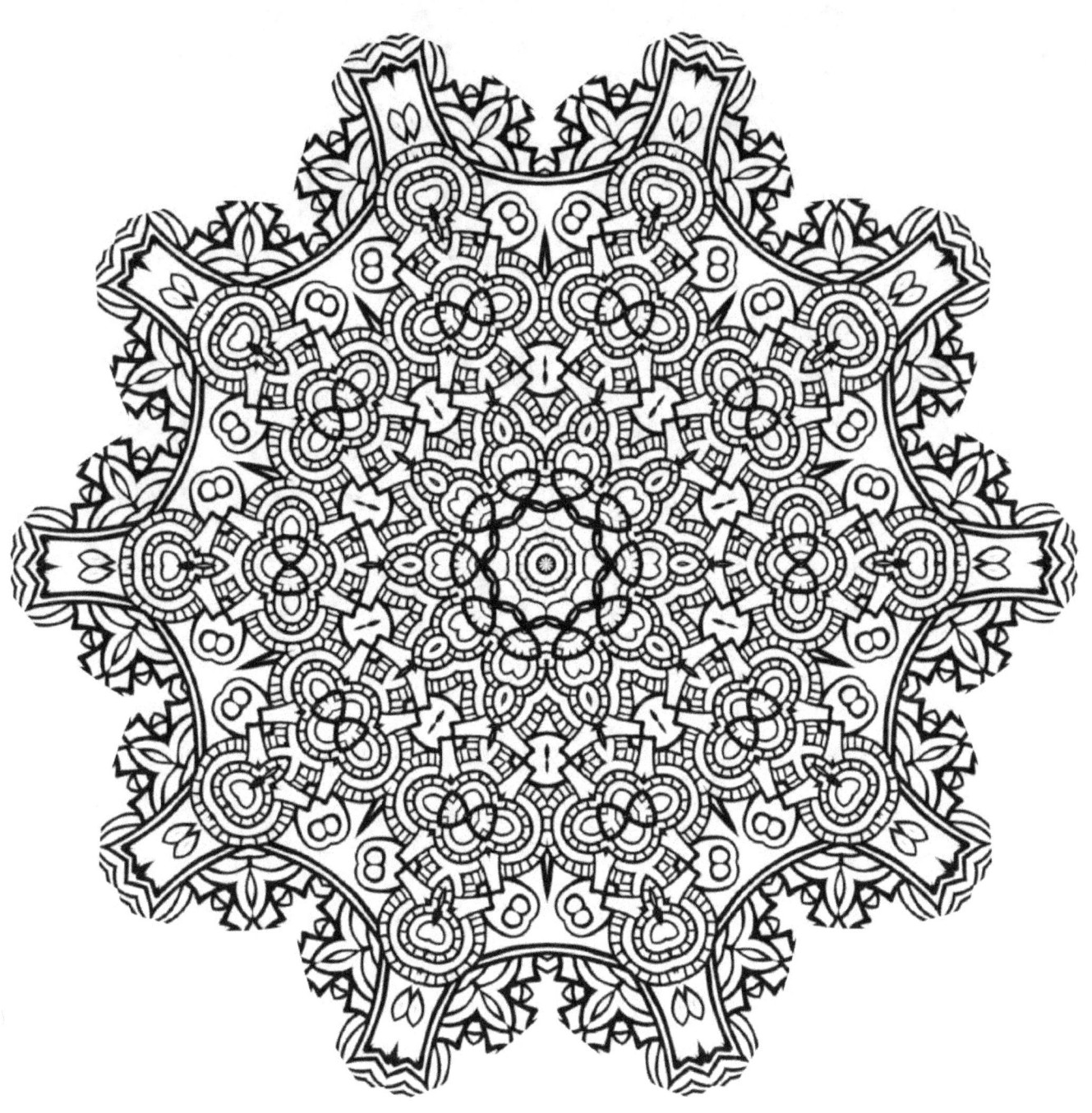

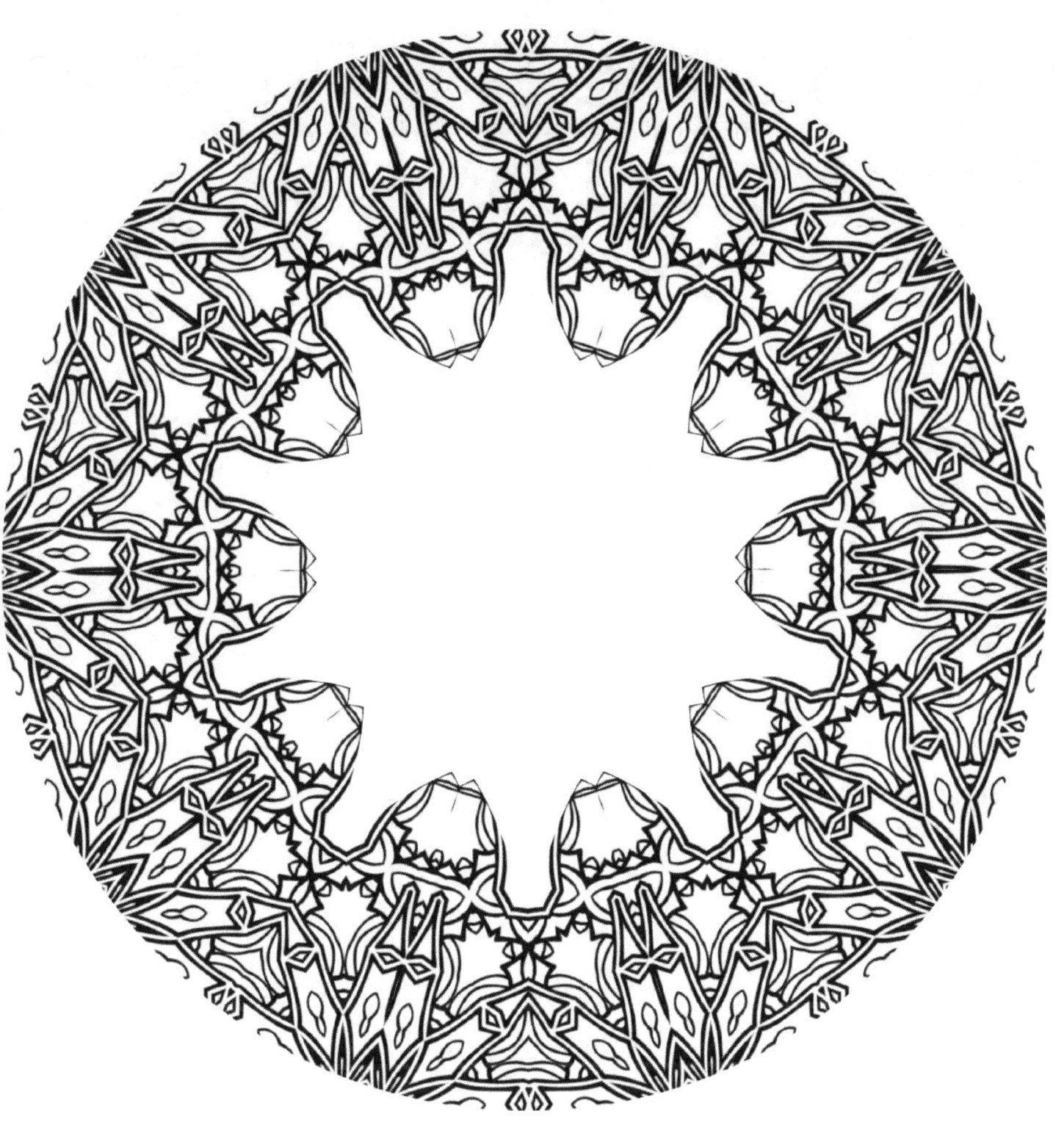

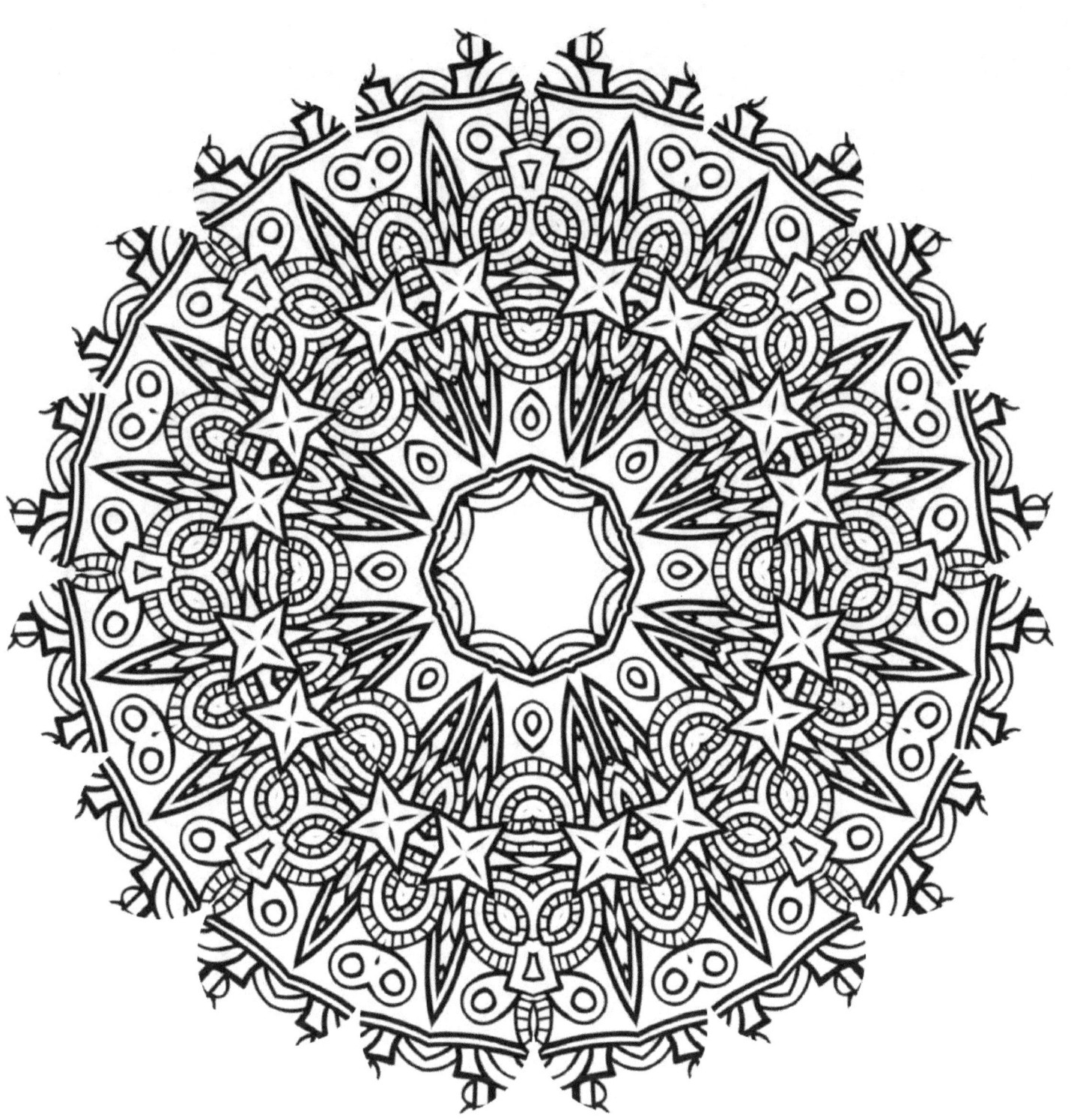

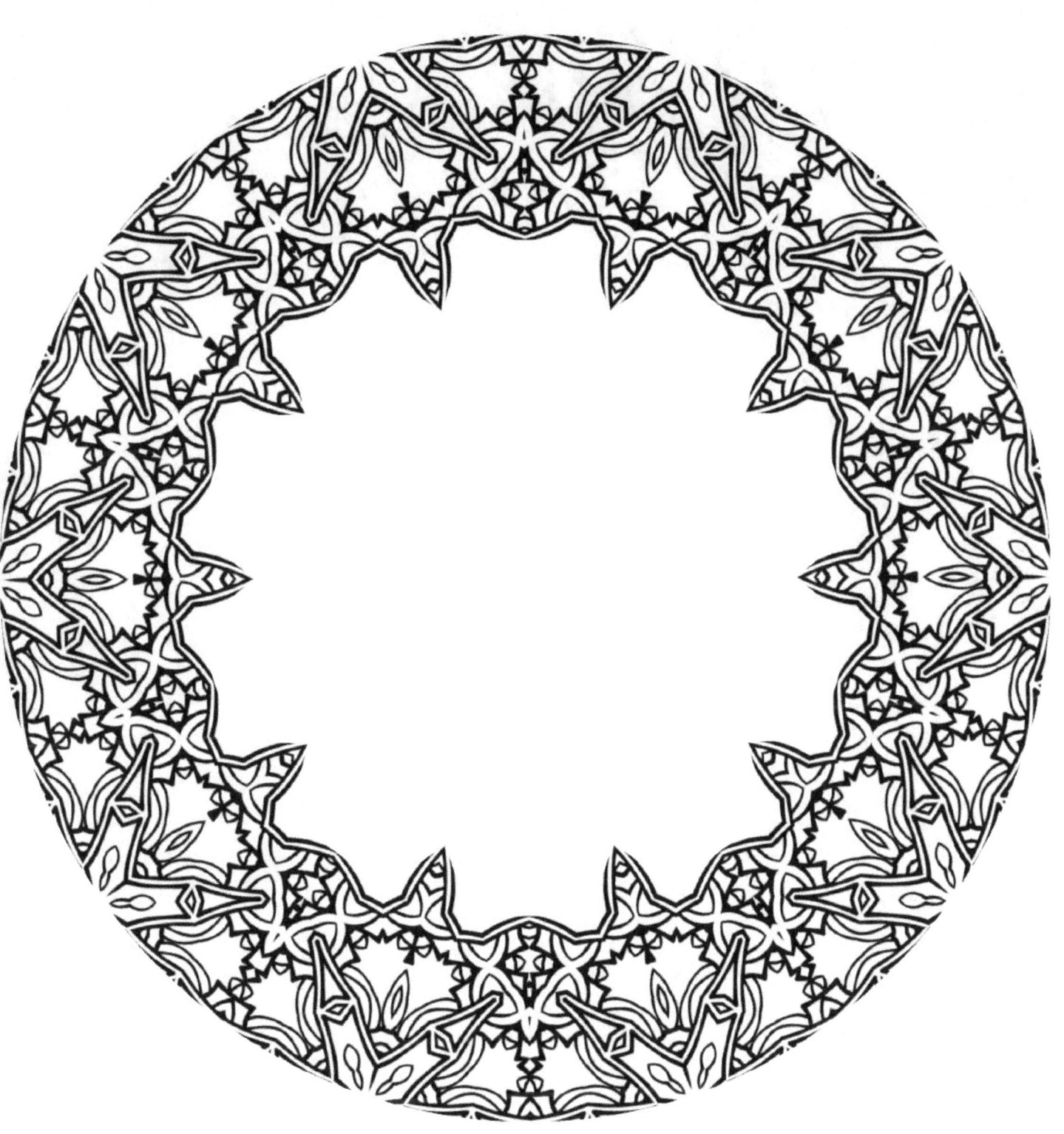

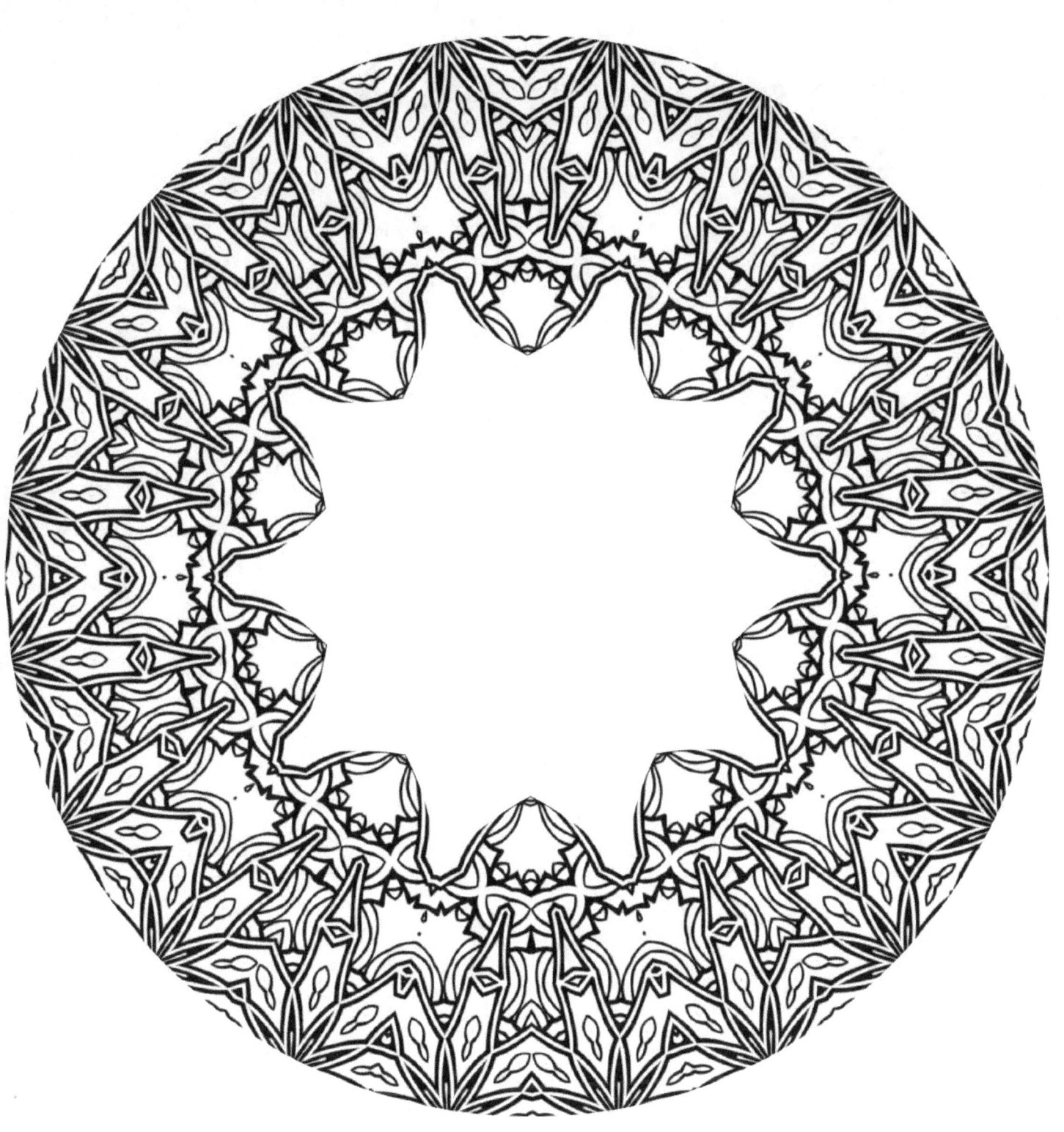

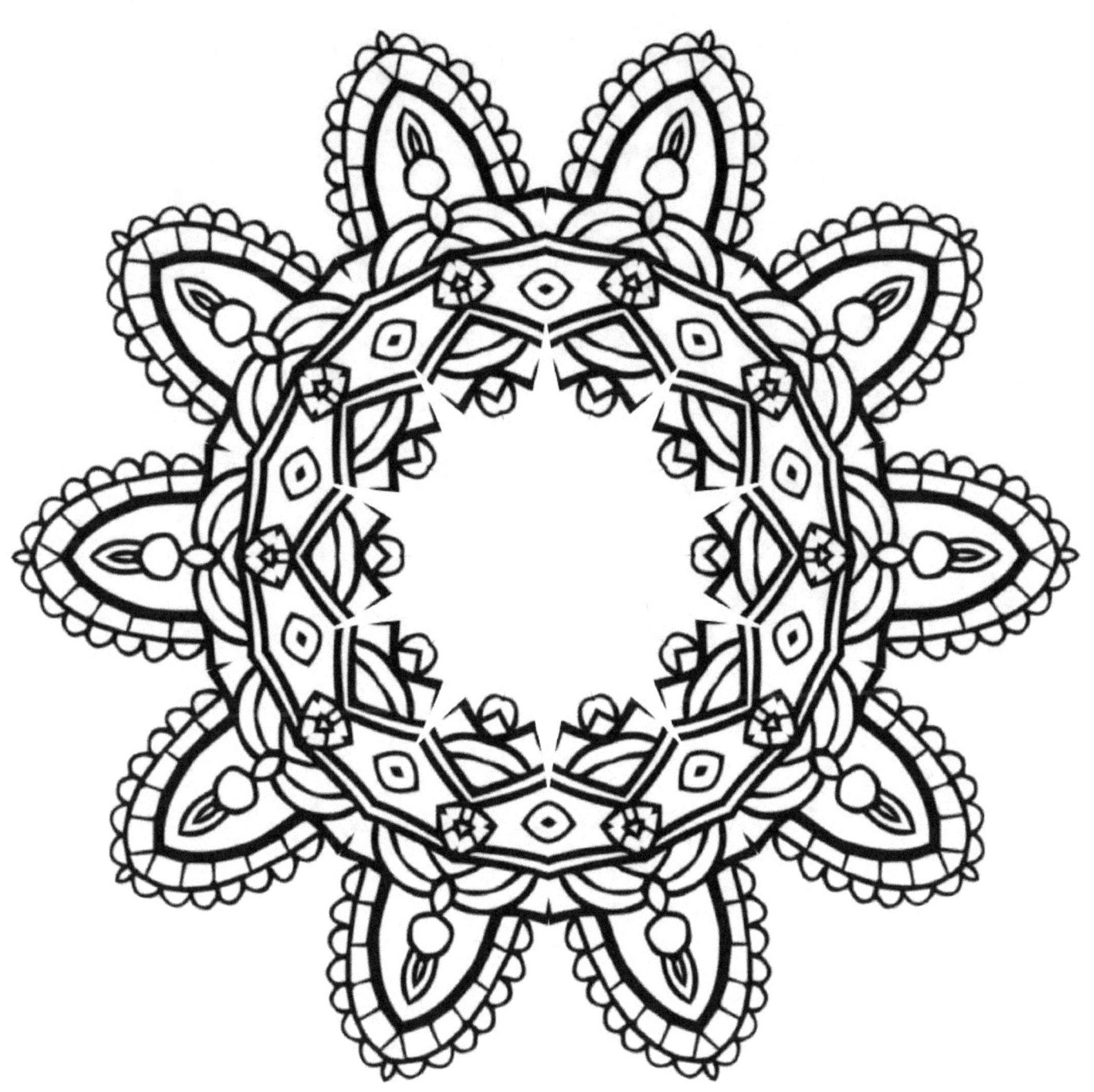

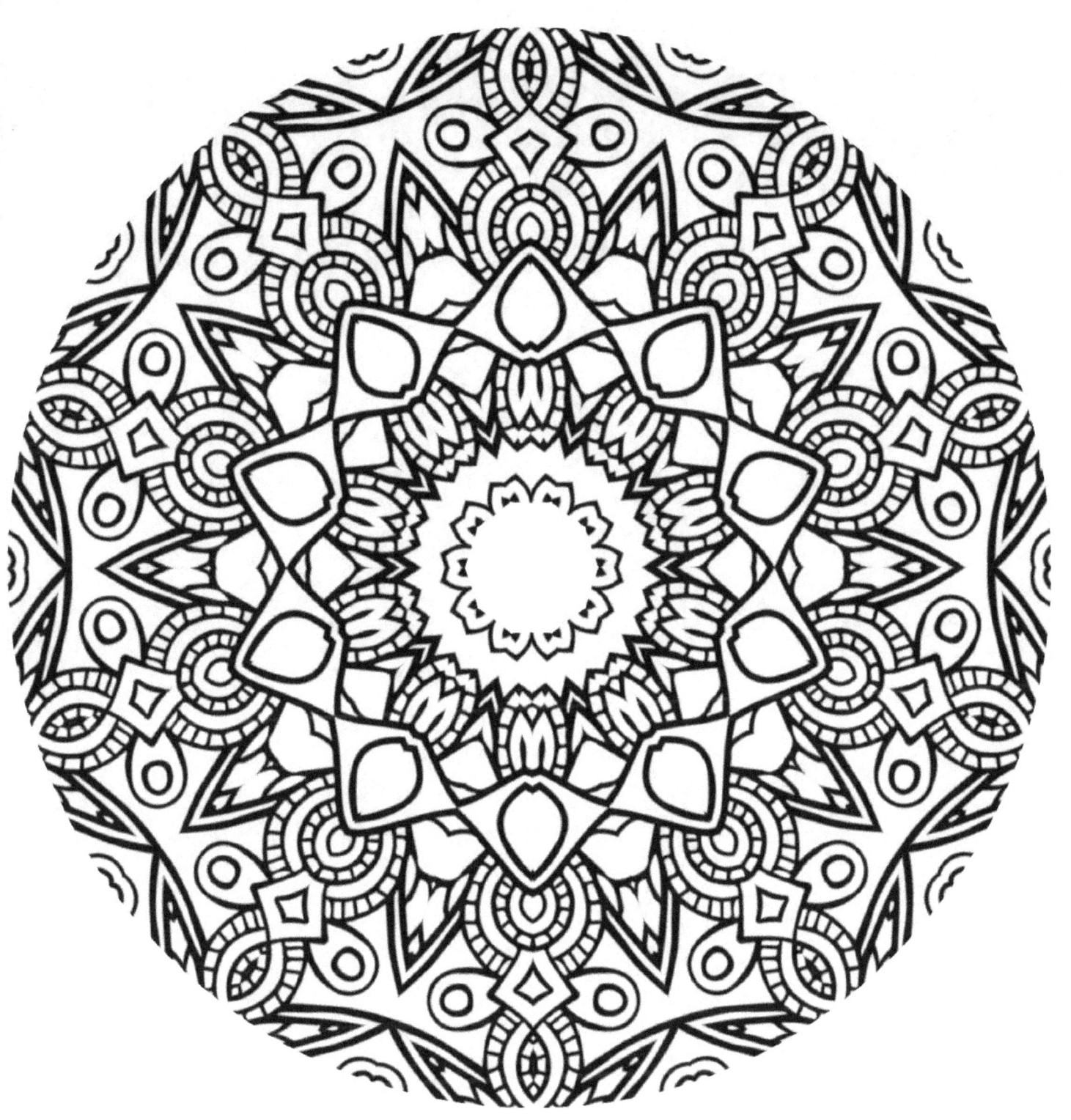

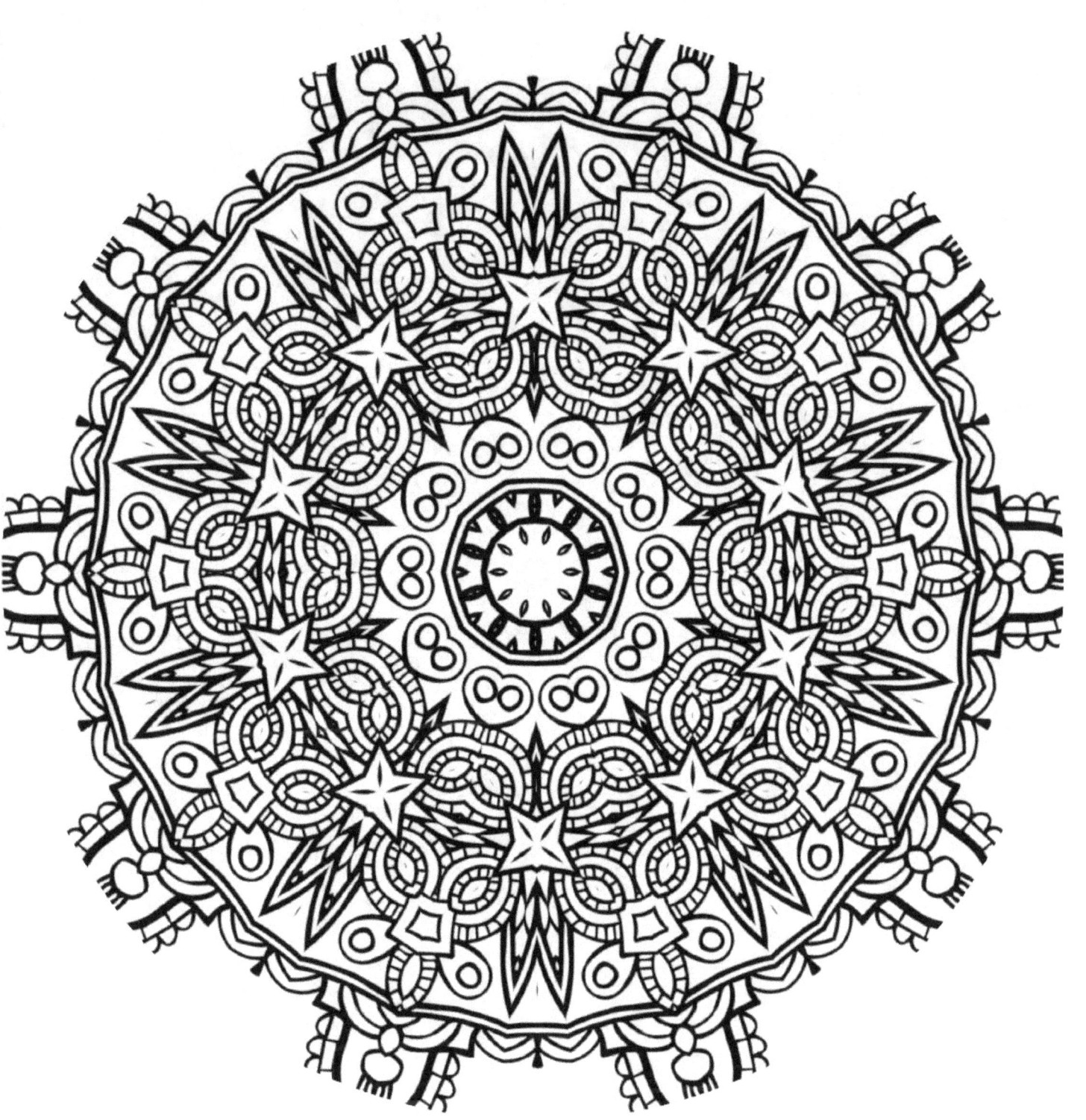

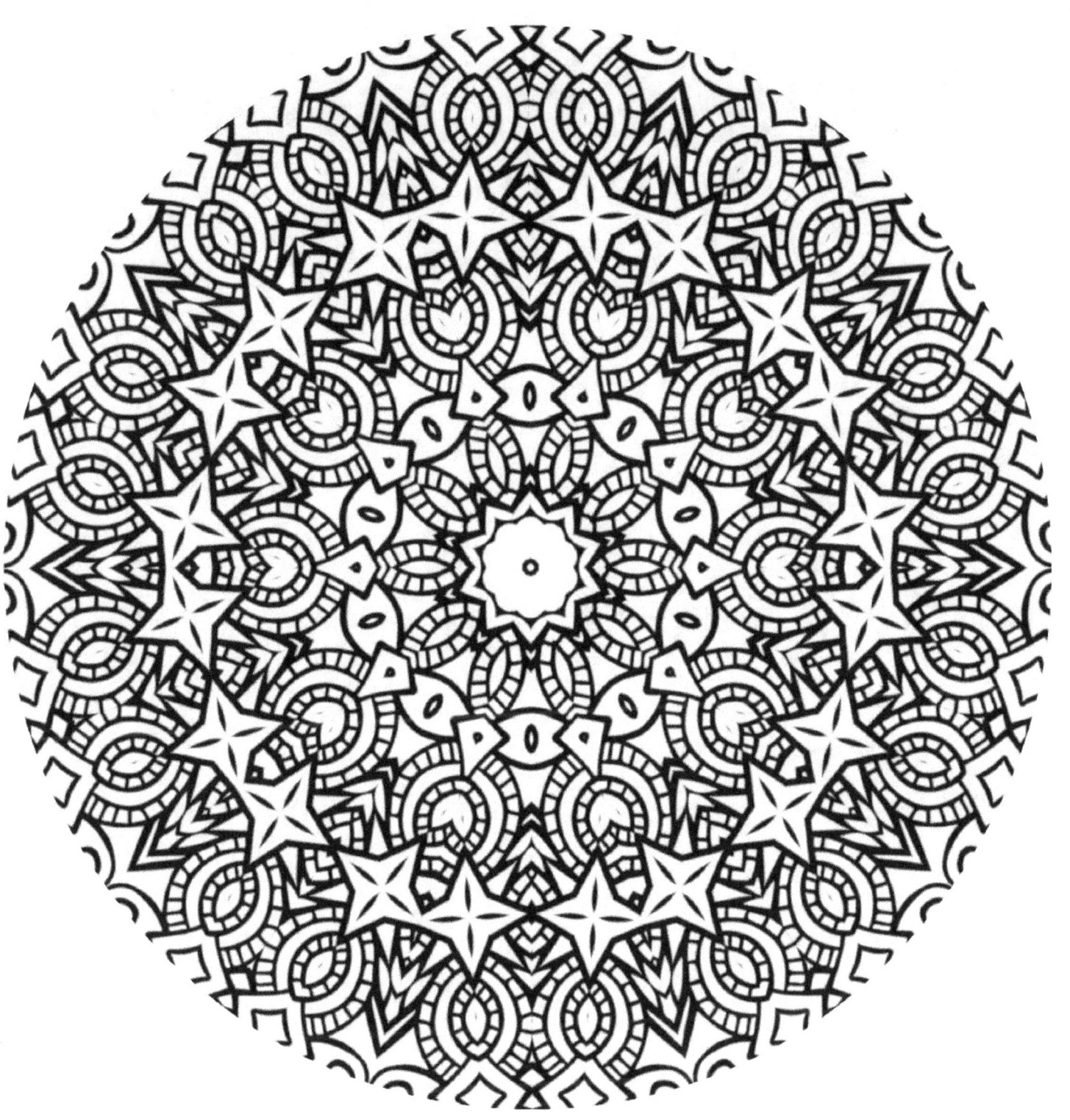

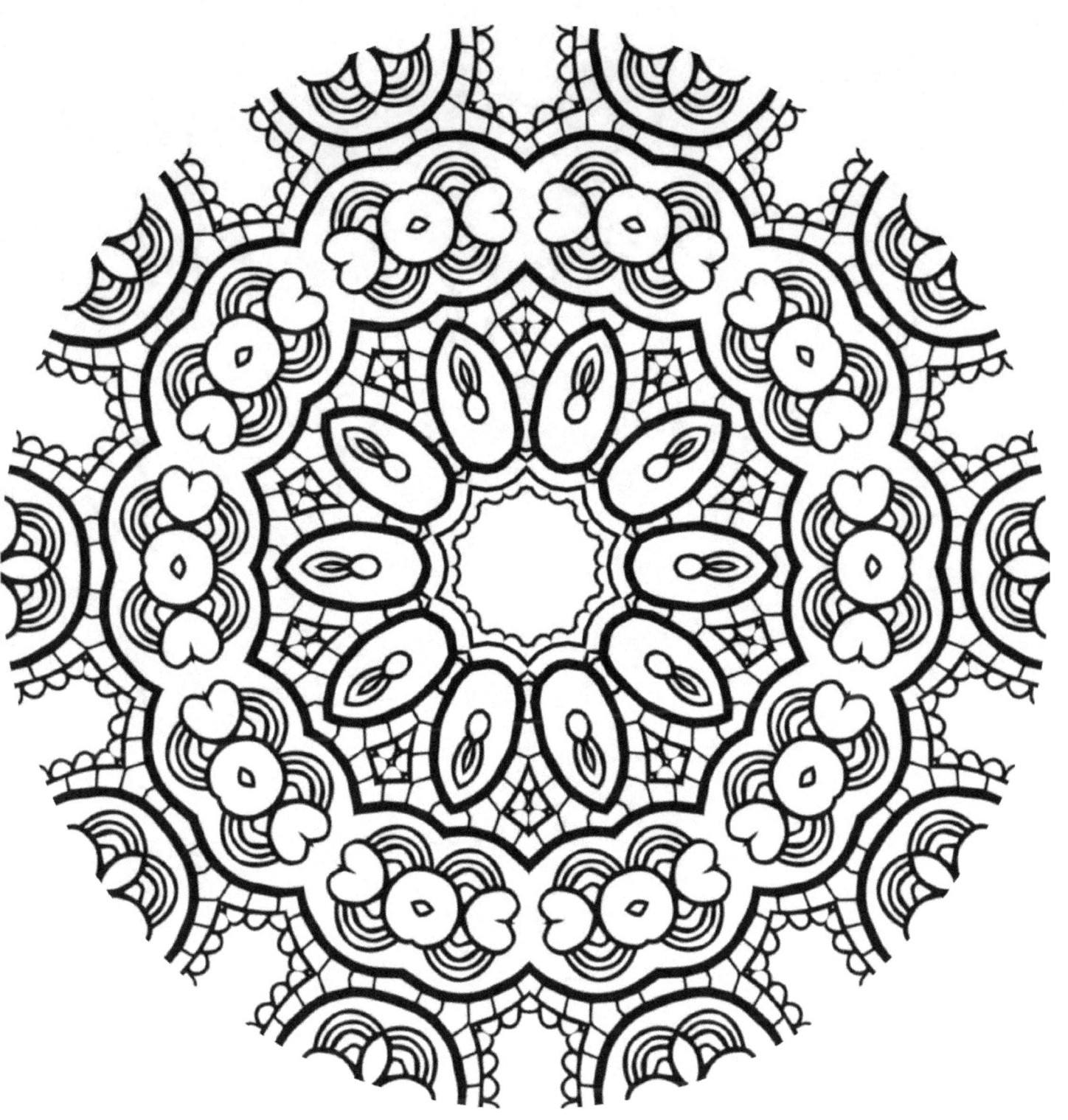

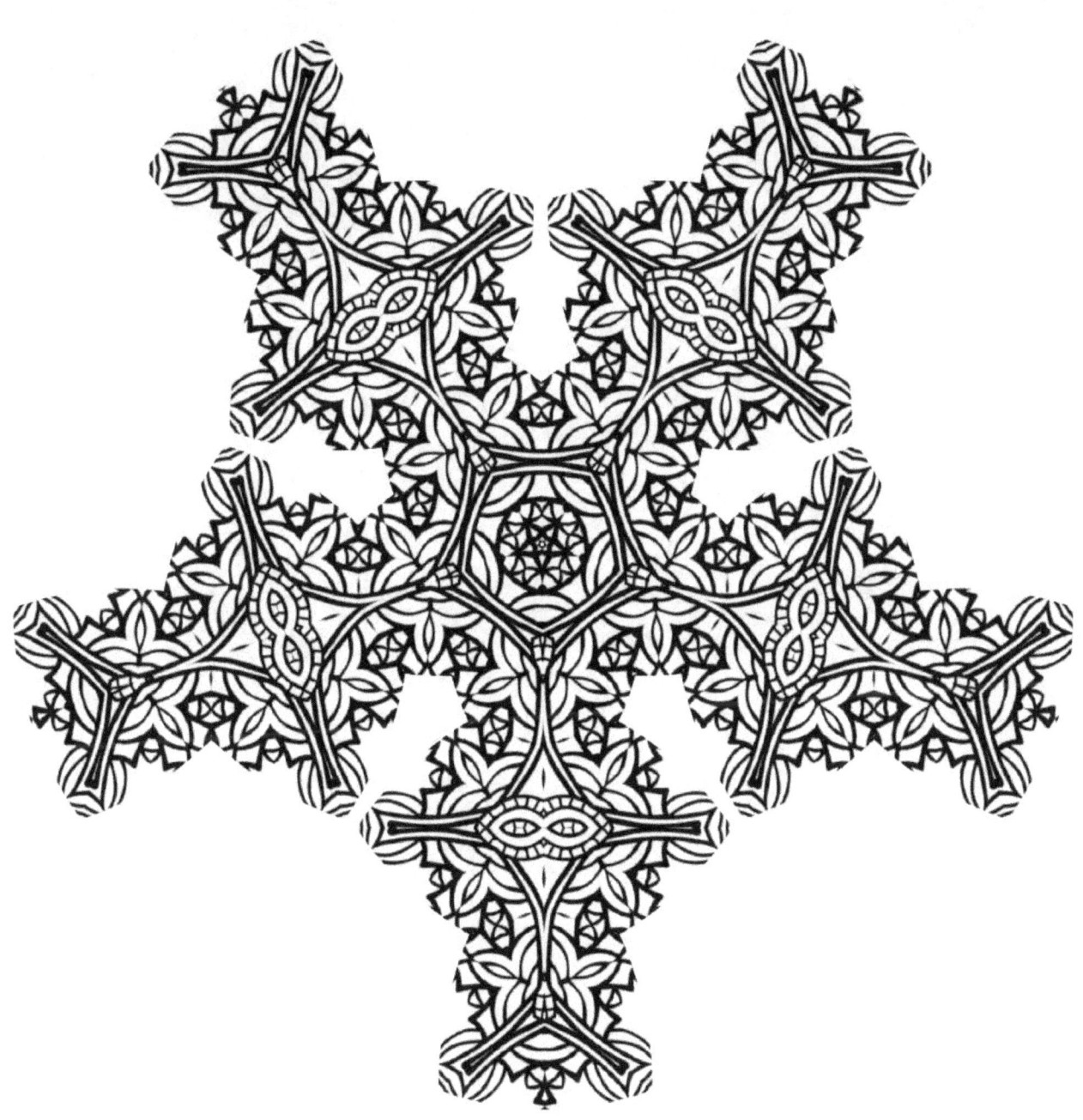

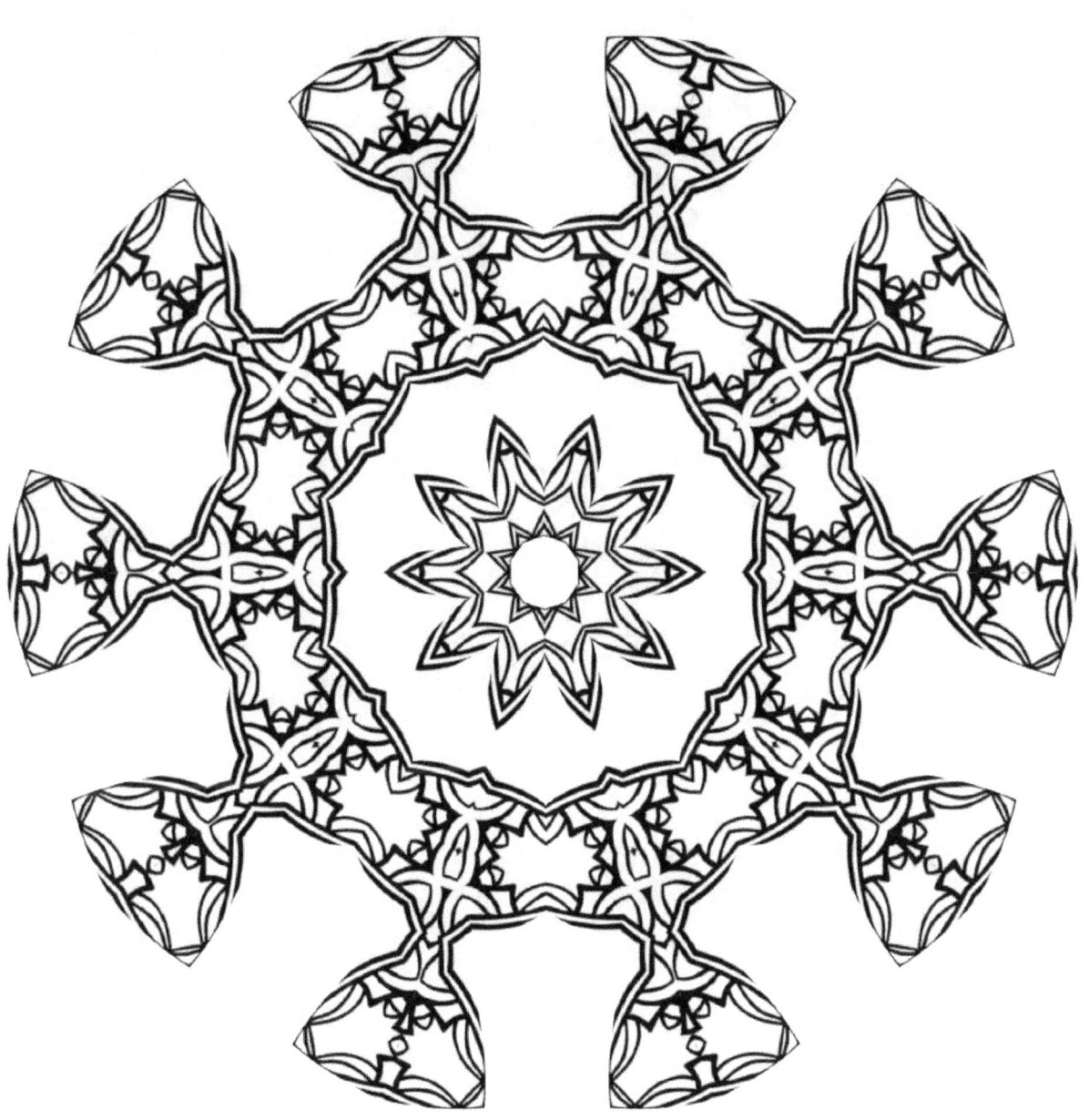

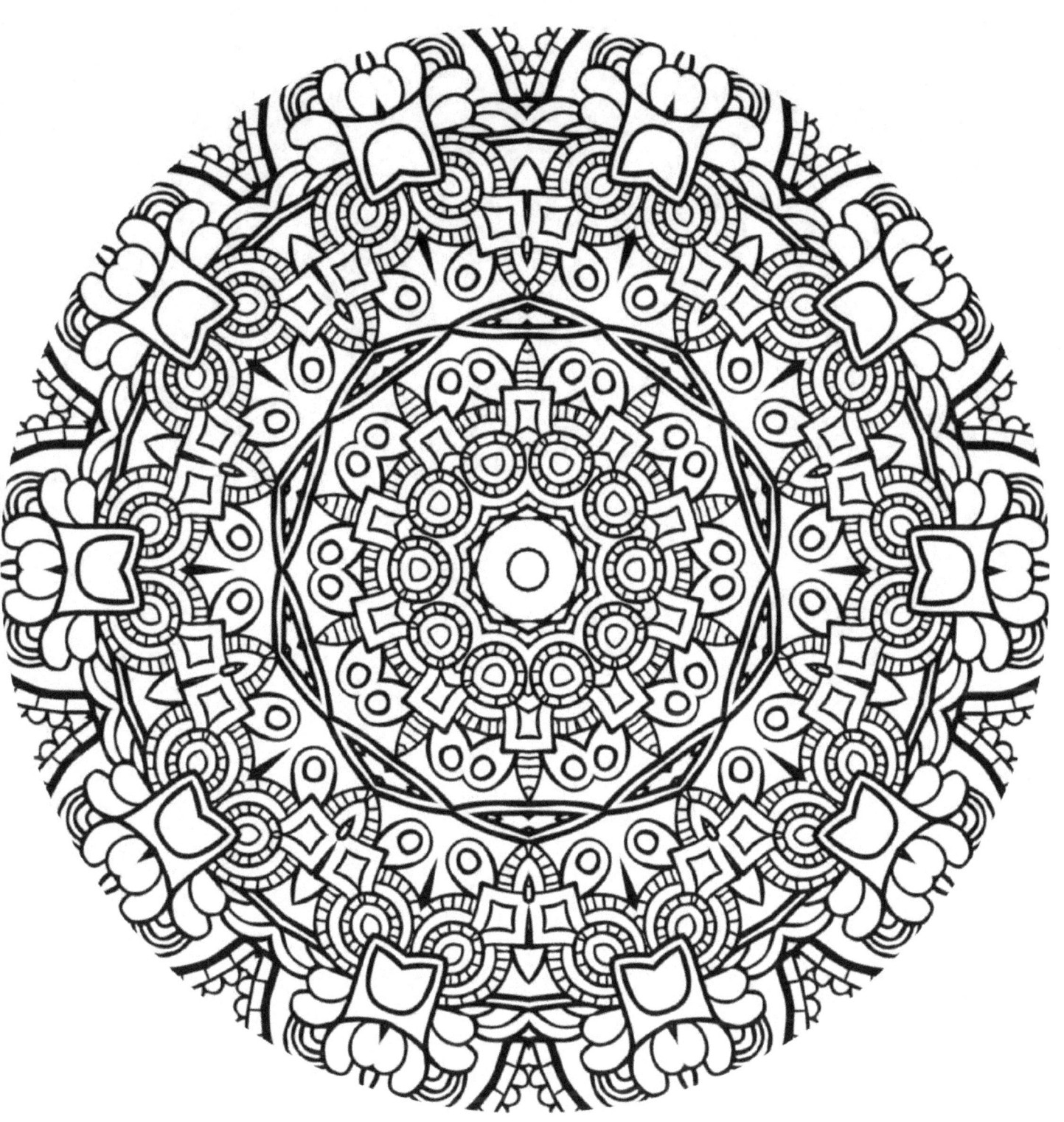

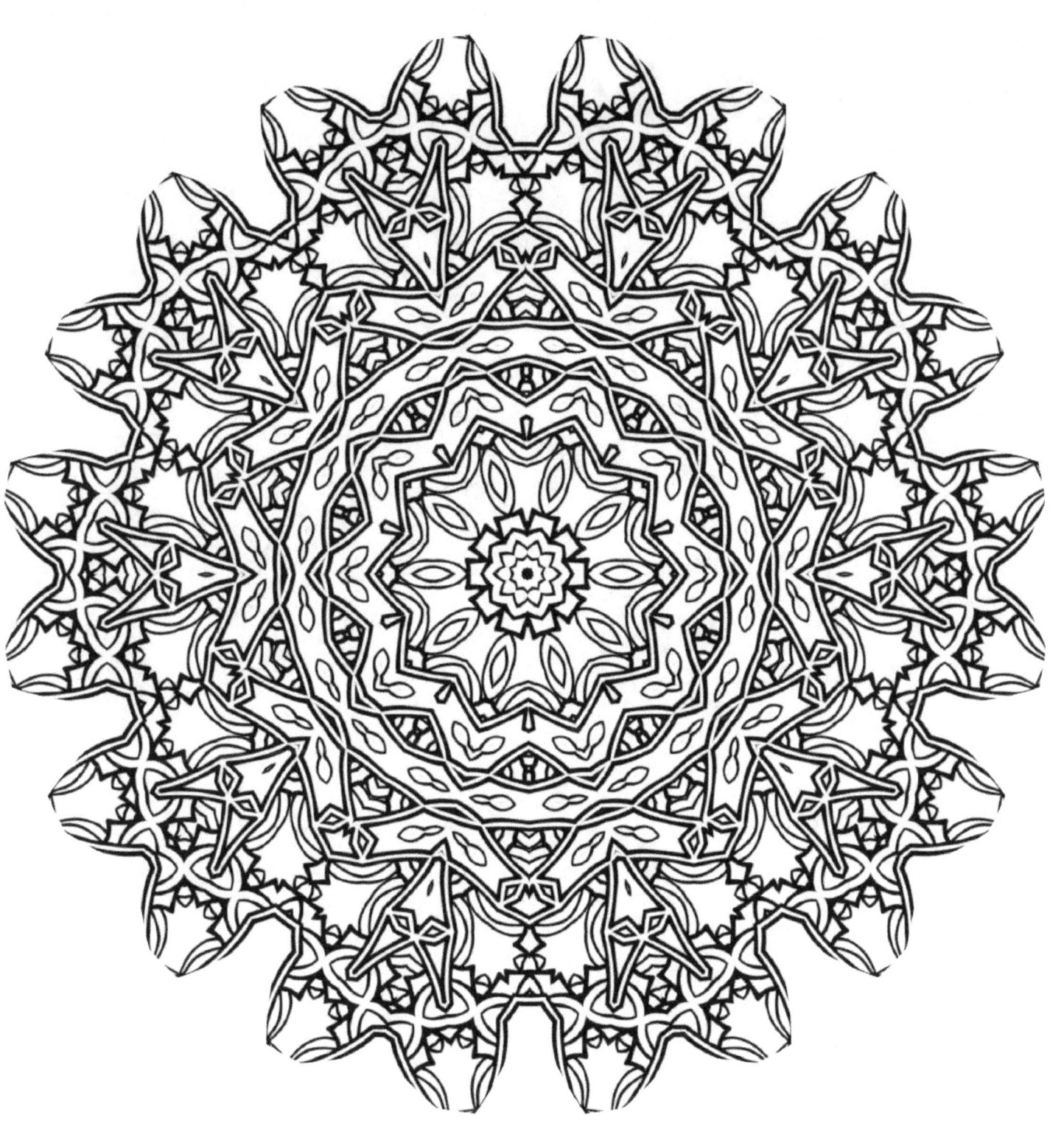

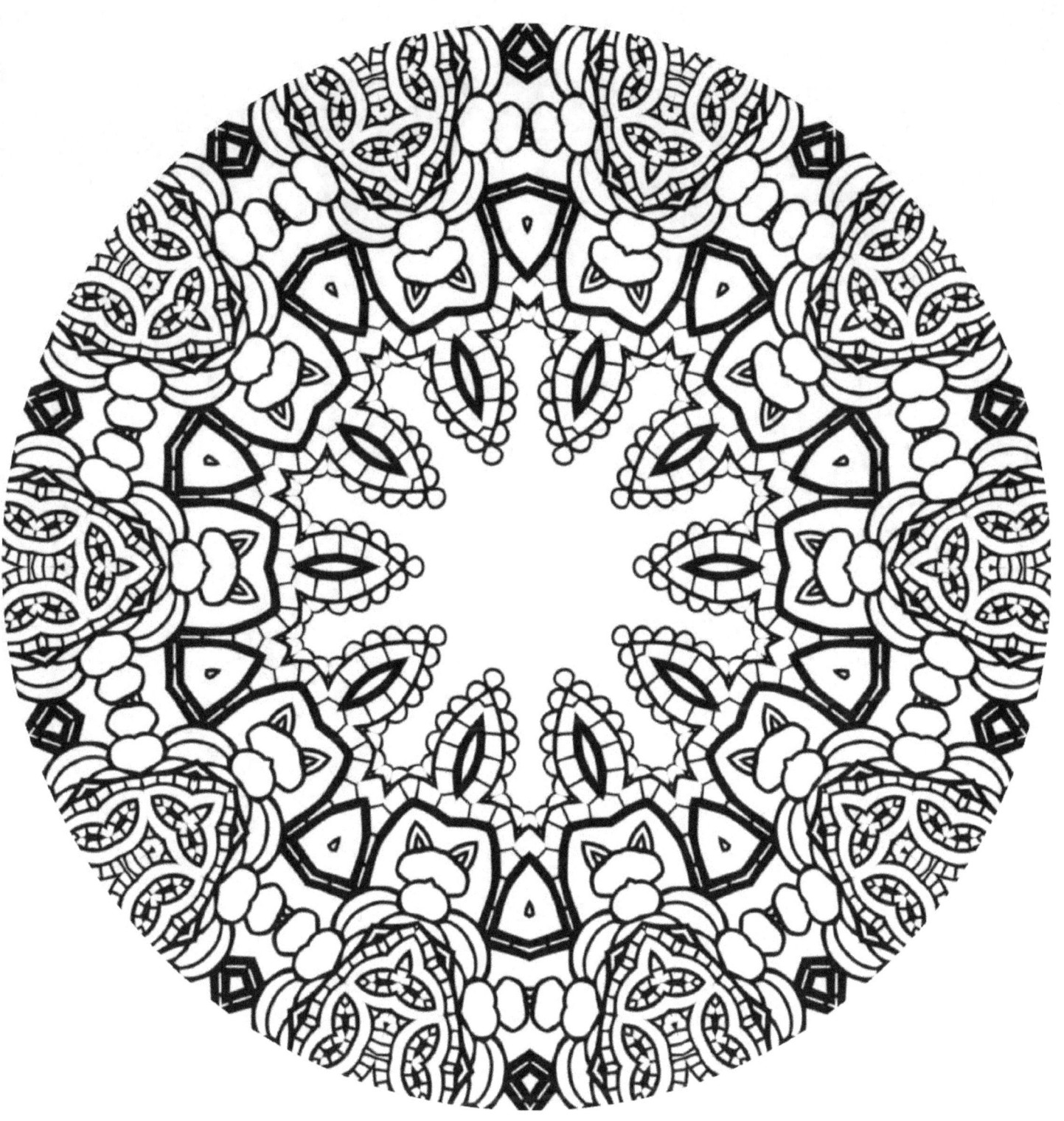

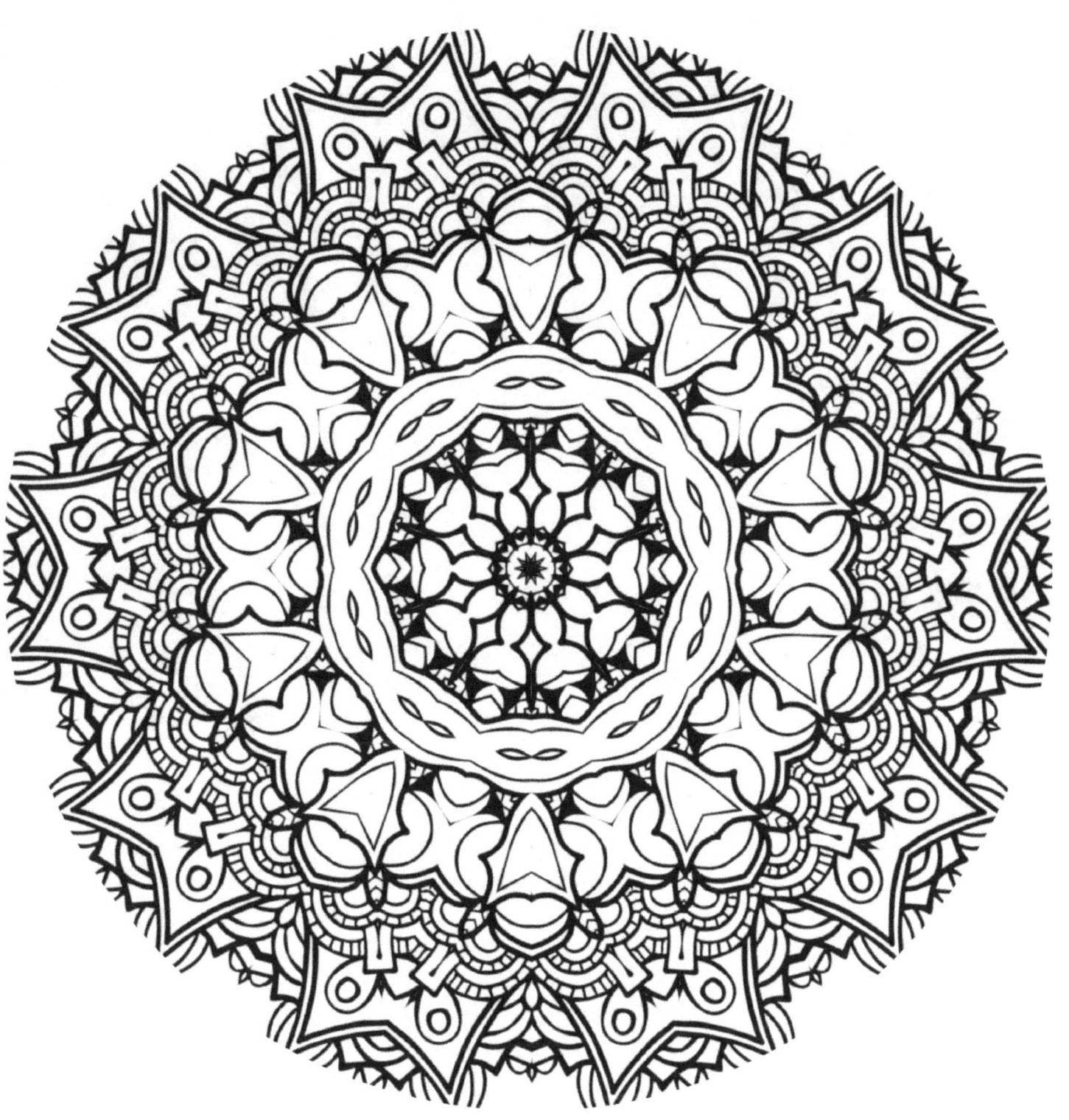

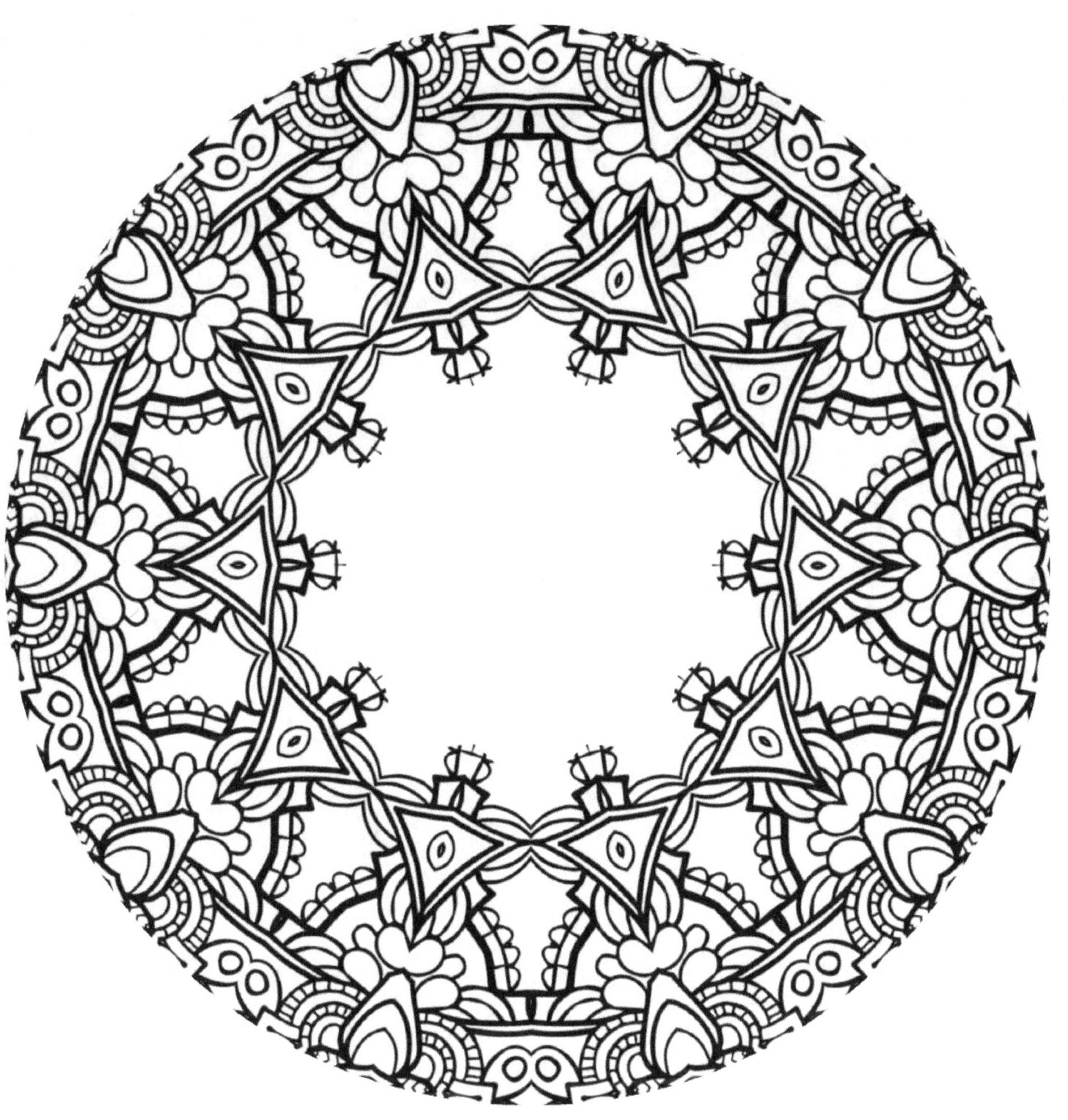

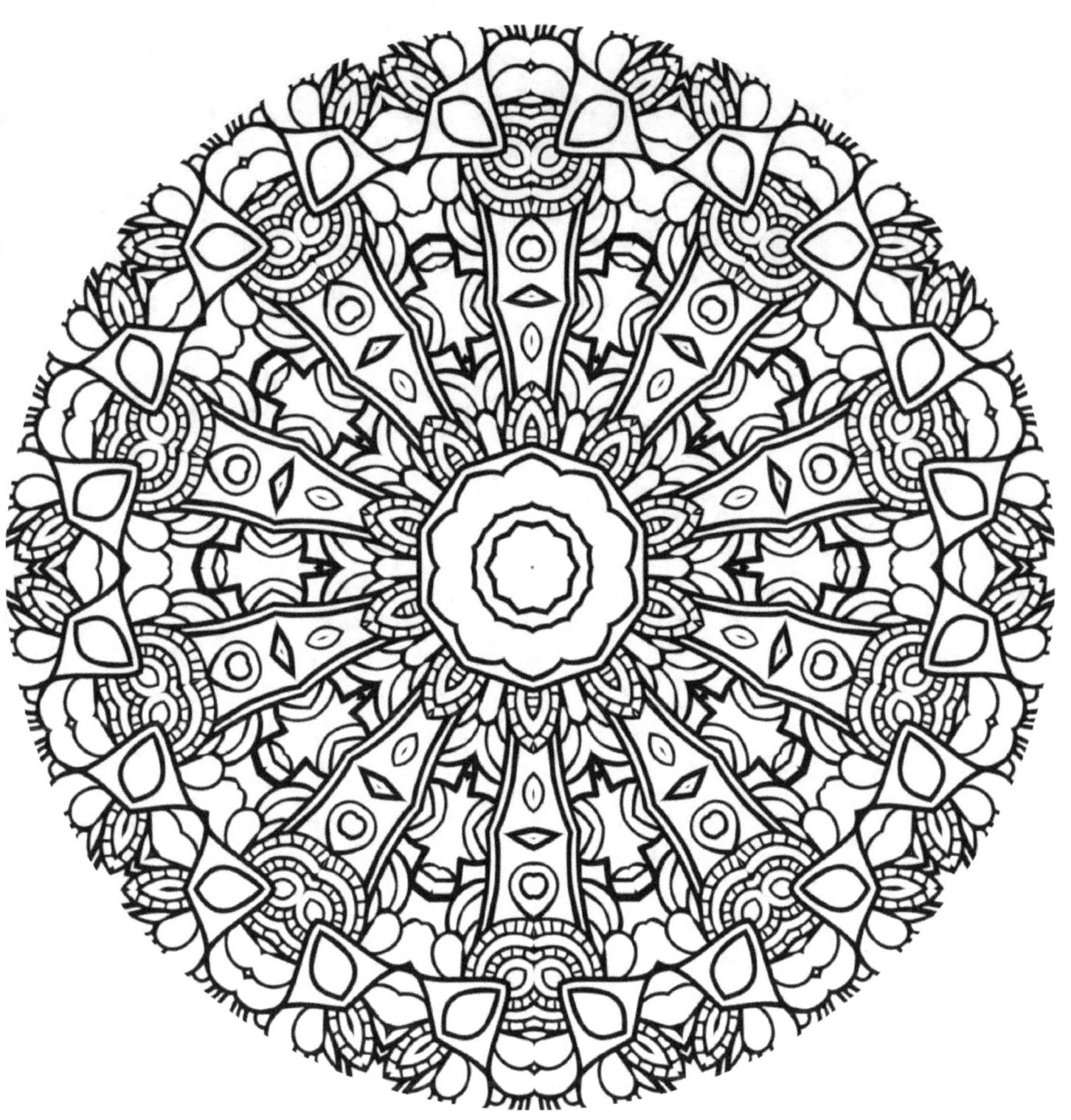

www.ingramcontent.com/pod-product-compliance
Lightning Source LLC
Chambersburg PA
CBHW080620220526
45466CB00010B/3402